DogStories

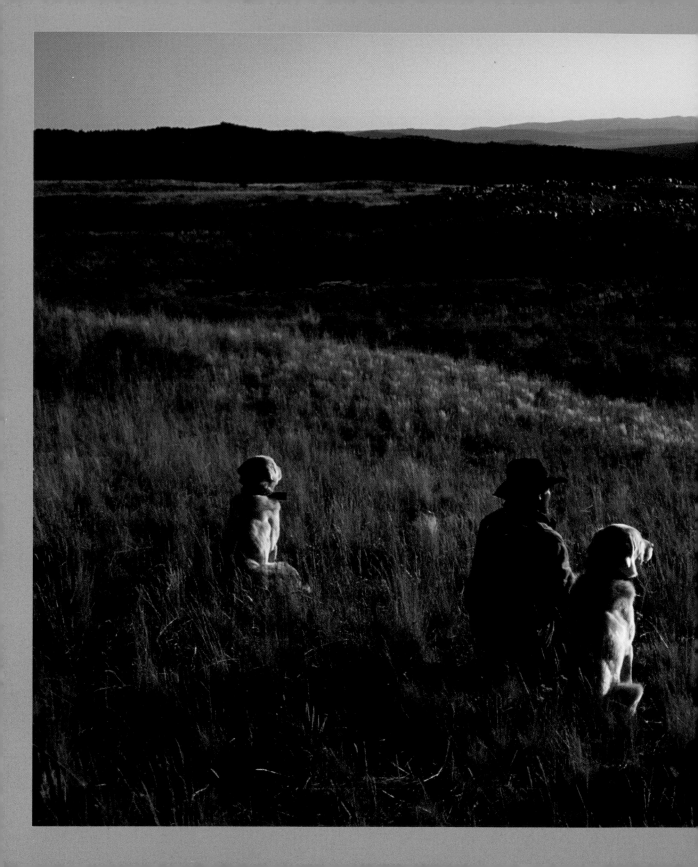

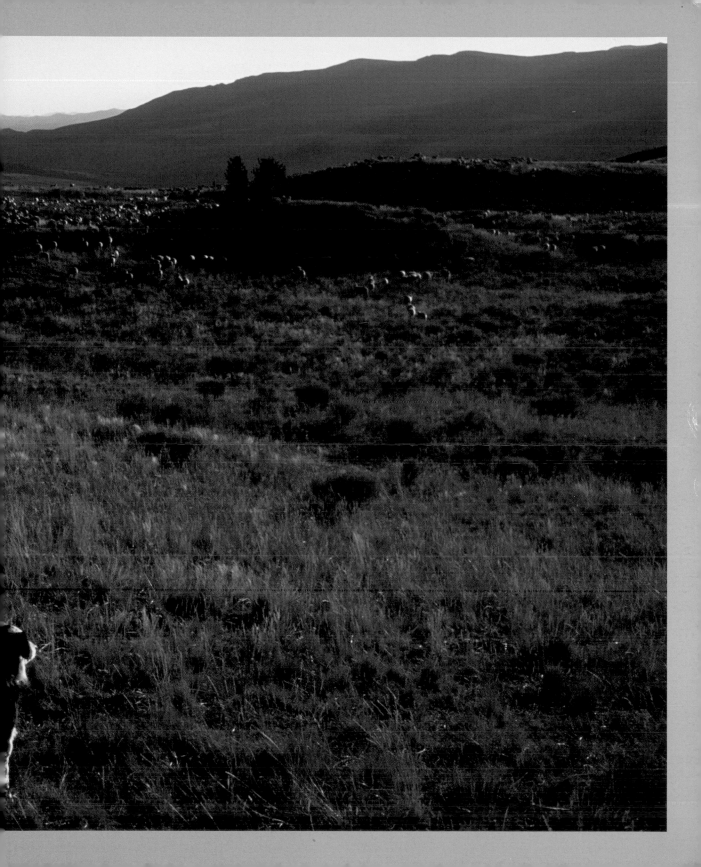

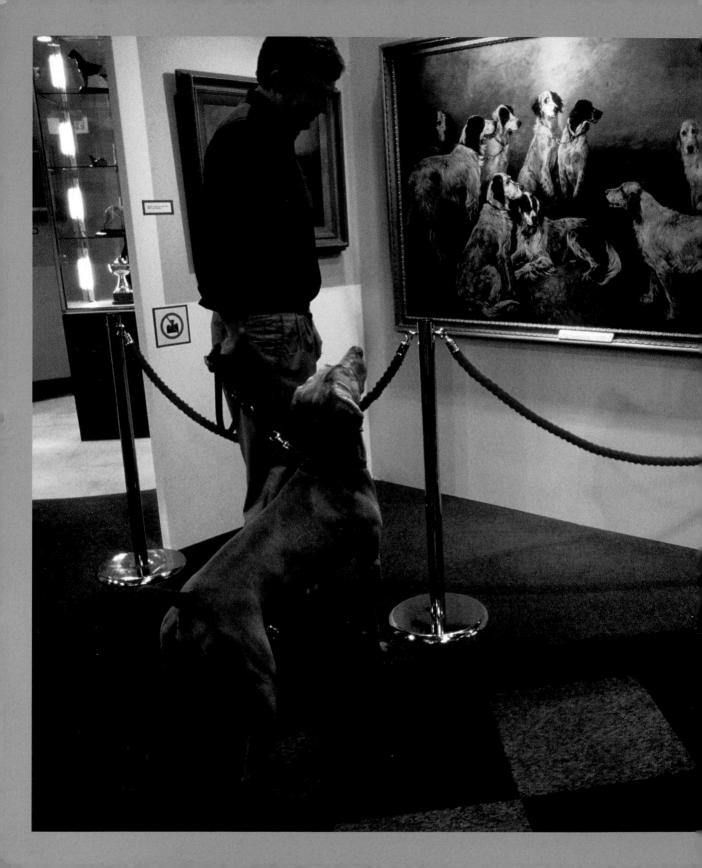

PRECEDING PAGES: Montana rancher John Helle watches his band of sheep from the west slope of the Gravelly Range, along with guard dogs Mugsy, Shaggy, and his Border collie, Pirate. Helle's sheep have summered in the high country, and tomorrow they will be moved across the 10,000-foot pass to their winter range near Dillon.

LEFT: Taking in some greatness at England's famous dog show, Crufts, a weimaraner and his owner admire an 1897 painting of champion English setters by John Emms.

RIGHT: Tiffy, a Maltese, waits patiently for her morning walk in the living room of her Upper East Side home in New York.

FOLLOWING PAGE: A Chihuahua tries to get her owner's attention at Fells Point, Baltimore, Maryland.

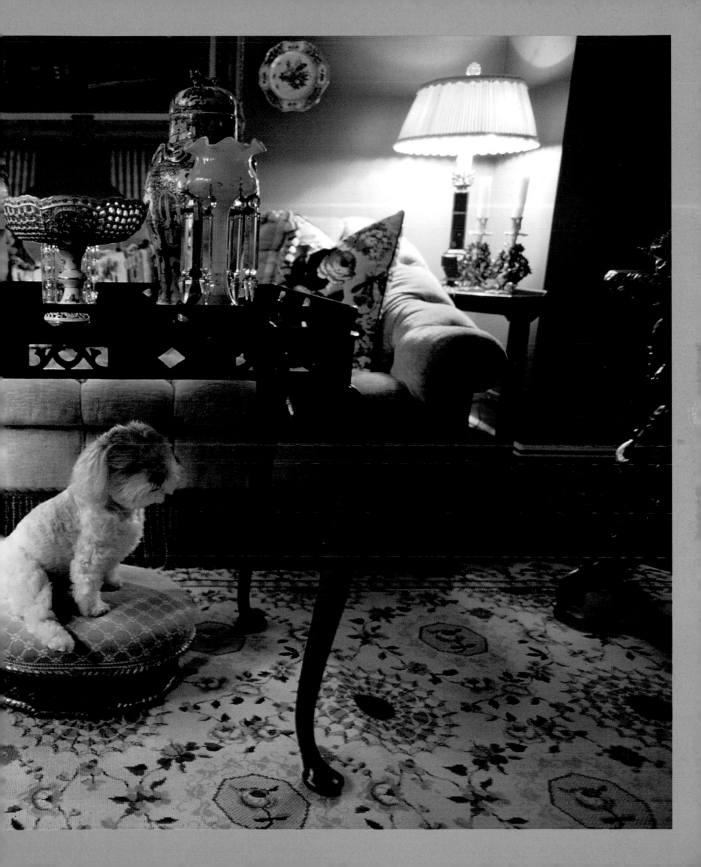

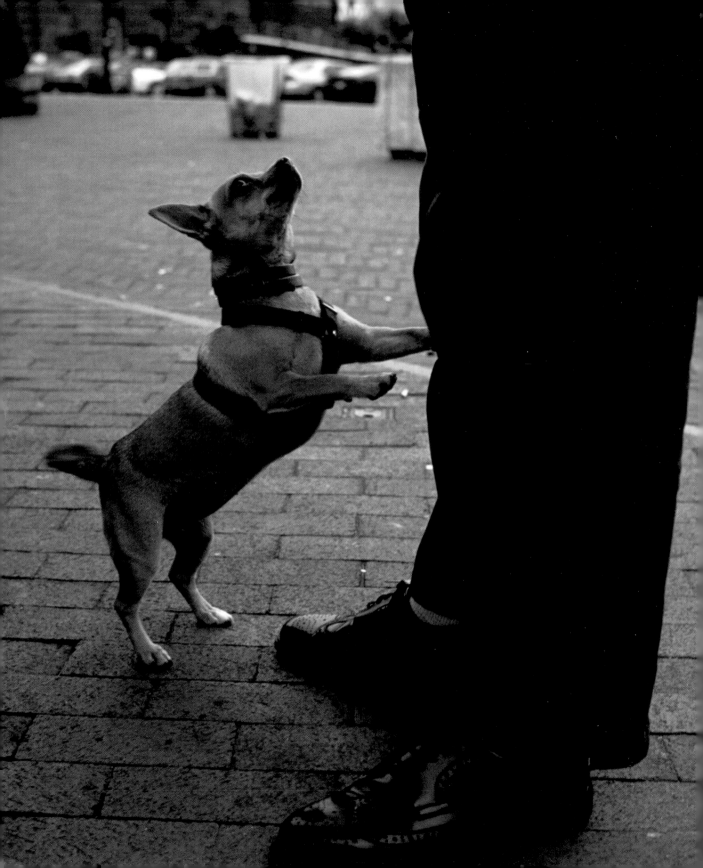

DogStories

Richard Olsenius

NATIONAL GEOGRAPHIC

WASHINGTON, D.C.

DEDICATION

To Nain Alysheba's Darkness.

Missed more than you will ever know.

Printed in Spain

 Library of Congress Cataloging-in-Publication Data

Olsenius, Richard, 1946-
 Dog stories / Richard Olsenius.
 p. cm.
 ISBN 0-7922-3371-9
 1. Dogs—Pictorial works. 2. Dogs—Anecdotes. 3. Photography of dogs. I. Title.

SF430.O47 2003
636.7'0022'2—dc21

 2003042002

CONTENTS

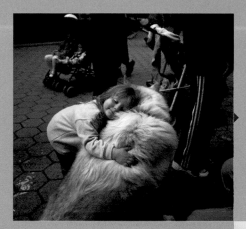

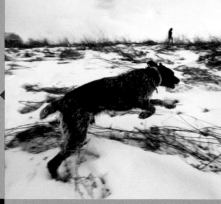

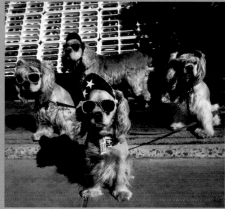

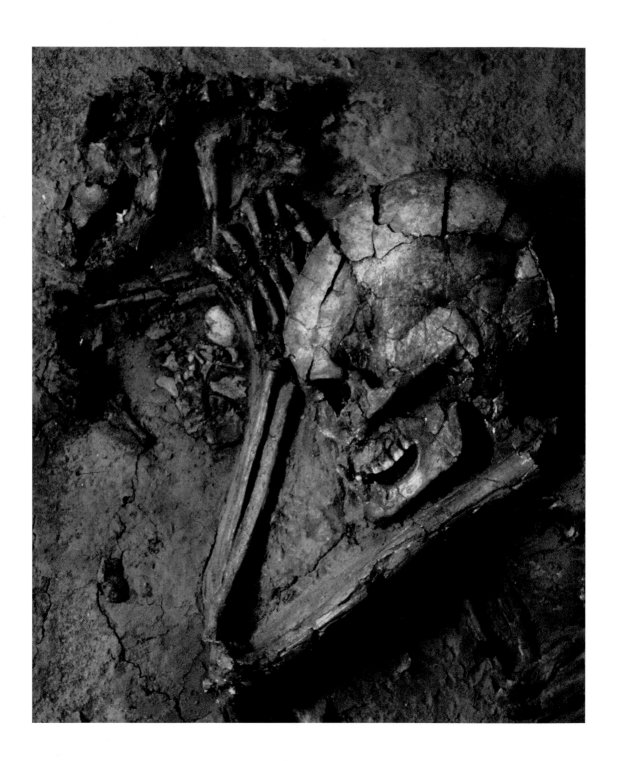

INTRODUCTION

By Angus Phillips

Every morning at about eight o'clock, barring a hurricane or blizzard, dogs by the score appear on a tree-studded knoll behind the Metropolitan Museum of Art in New York City. Trailing dutifully behind are their owners, who with great relief release the pets from their restraints and let them run free.

Technically that's illegal, as all dogs in Manhattan are supposed to be leashed except when in a handful of fenced, designated dog parks. But dogs must run, and like all big cities, New York has unspoken rules within its written rules to accommodate the immutable forces of nature. Dog owners on the Upper East and West Sides know leash laws are enforced in Central Park only between 9 a.m. and 9 p.m.

So folks rise early, wipe sleep from their eyes, and gather for a cherished hour, bringing along a wildly eclectic assortment of dogs to frolic in the shadow of the "Needle of Cleopatra," an Egyptian obelisk built in about 1600 B.C. and donated to the city in 1881. Around and around the towering stone structure run everything from scrawny miniature Dobermans to giant bull mastiffs, yappy schipperkes, bichons frises, terriers, stylish Irish and English setters, and plenty of mutts, the adoption of abandoned pound pups being a highly prized social marker in New York these days.

The king of them all, according to his proud master, is an enthusiastic, curly-tailed basenji named Filou. "He's the king because he loves to run," says Patrice Bertin, a French expatriate who works alone restoring fine art for a living in his East Side studio and keeps Filou for company. "He runs and the others all follow."

The remarkable spectacle of dogs in so many shapes and sizes racing loose, yapping, barking, mauling each other happily but rarely squabbling, plays out daily under the loom of skyscrapers and amid the clash and clatter of commuting hordes on their way to work in the center of American commerce. It raises the question, what makes

Natufian woman and dog from 10,000 B.C., Houleh Museum of Pre-History, Israel.

dogs so attractive that people will go through difficulties in order to keep them in the most trying circumstances, sharing space in small apartments in one of the world's busiest and most crowded places?

The answer almost invariably is simple: companionship. In a recent survey of U.S. dog owners, 94 percent listed it as the key benefit of keeping a dog, while only 6 percent said they hunted with dogs and 4 percent used them in farming. In New York City, where no one farms or hunts, almost 100,000 dogs are registered, and officials estimate unregistered dogs outnumber the ones with tags by about three to one, so the total is likely about 400,000. That figure alone is a testament to the enduring appeal of our oldest animal friends.

People and dogs, dogs and people. It's a coalition so ancient, the origins came long before humans began keeping records. Robert Wayne, a geneticist at the University of California at Los Angeles, says wolves have been around for 1 to 2 million years and some sort of dogs began breaking away from their wolf progenitors about 100,000 years ago. But when and how humans and dogs or wolves started to coexist for mutual benefit remains a mystery.

The earliest hard evidence of a connection dates back about 12,000 years, according to scientists. The first archaeological record of humans interacting directly with dogs or protodogs is a burial site from around that time in what is now Israel, in which a human arm cradles the skeleton of a pup. Other evidence suggests the early glimmers of coexistence began at least 14,000 years ago, perhaps farther back, when wolves or early dogs made their way close to fire rings of nomadic hunter-gatherers, doubtless attracted by the smell of food.

They would eat almost anything then, and still do. The digestive tract of the dog remains one of the world's great wonders. Meat too rancid for humans to bear a whiff, bones with nothing but a few strands of tendon left, even a dog's own excrement can be appealing treats to the canine palate. The ability to digest such disgusting stuff is a key to their survival and to their long association with people.

The widely accepted theory is that wolves or protodogs sidled close to early human encampments to scavenge garbage and leftovers, and the gentlest and least threatening of them eventually were permitted to draw inside the fire ring and stay. Any parent who has tried to withstand the wails of a distraught child over a stray puppy knows the hopelessness of that effort, and pitiful abandoned puppies may have been the first to get their fuzzy paws in the door. These in turn would have developed through inbreeding into the

sort of generic, moderate-size, brownish, curly-tailed dogs that still roam in packs in less developed corners of the globe.

The ones that became best socialized were integrated into human groups and would have brought valuable skills and talents to the mobile encampments. With their superior scenting ability and speed, they could help hunters track and kill game; their keen senses could warn of danger approaching, just as barking dogs in homes warn of intruders today. They would provide warmth on cold nights and, in hard times, could even be sacrificed for food.

So would have begun the process of domestication that leads to modern times, when dogs in hundreds of varieties are linked to humans almost everywhere on Earth. In the United States alone are an estimated 68 million dogs, one for every four people. A few still earn their keep as guards or hunters; some are used to sniff out drugs or other contraband, and some are "helper dogs," trained to assist people with infirmities or special needs. But for the most part, pet dogs do little for their daily pound of grub.

"Ninety-nine point nine percent of them do nothing but lie around the house, bark, and eat," says contemporary writer Stephen Budiansky in his book *The Truth About Dogs,* in which he suggests modern dogs get more from the relationship than their masters do. Budiansky should know—he keeps three dogs that do little but lie around his house, bark, and eat.

The phenomenon of do-nothing dogs occupying places of honor in human society is relatively new. Indeed, in some developing nations dogs remain unloved hangers-on that linger on the edges of villages and towns, still scratching a living from handouts and by digging through refuse dumps and stealing scraps.

The historical record of dogs and humans interacting begins with the Egyptians around the fourth millennium B.C. Rock and pottery drawings from that time show hounds hunting with men, driving game animals into nets. In ancient Greece, 350 years before Christ, Aristotle described three types of domesticated dogs, including speedy Laconians used by the rich to chase and kill rabbits and deer. Three hundred years later, Roman warriors trained large dogs for battle. The biggest and strongest were said to be able to knock armed men from their horses and dismember them.

Dogs were not well loved during the Dark Ages, when they appalled the public by scavenging corpses of plague victims. But by the second millennium they were being used by British royalty to chase rabbits and stags. In the meantime, dogs were put to thankless jobs by the working class. They were harnessed and turned out to pull

wagons, sleds, and plows; they herded livestock; and they turned spits on which joints of beef and venison were roasted over open fires. These so-called turnspits often toiled until they dropped; their laboring kin were usually hanged or drowned once they got too old or weak to perform.

It wasn't until the 17th century that so-called unnecessary dogs came into favor with British royalty. King James I was said to love his dogs more than his subjects; Charles II was famous for playing with his dog at Council table, and his brother James had dogs at sea in 1682 when his ship was caught in a storm. As sailors drowned, he allegedly shouted, "Save the dogs and Colonel Churchill!"

The royal penchant for furry, barking playthings eventually rubbed off on the general populace, as royal penchants will, and Britons began keeping canines as pets. As certain breeds came into favor, breeders began tailoring bloodlines in earnest, and private registries were formed to protect those lines.

The Kennel Club was founded in England in 1873 and the American Kennel Club was formed in the United States in 1884. The number of dog varieties subsequently exploded. Today, the AKC recognizes 150 breeds, the Kennel Club registers 196, and Europe's Federation Cynologique Internationale recognizes many more than that.

How did the dog population get so diverse, growing from just a few distinct types in ancient Greece to hundreds in the modern age? Humans did it, says Jeff Sampson, a British molecular geneticist and the Kennel Club's genetics coordinator. Because dogs have almost twice as many chromosomes as humans (78 to humans' 46), he believes the opportunity to mix and match them is enhanced. Humans have been the great mixers and matchers, selecting for desired size and features by breeding dog types together, then ruthlessly discarding the ones that did not fit the profiles they were seeking.

The upshot today is a dizzying array, from tiny, two-pound Chihuahuas to mastiffs weighing hundreds of pounds and standing tall and strong enough for a child to ride. If humans exhibited the same degree of size variation, the smallest of us would weigh twenty pounds and the largest a ton.

And what do modern humans get out of the amazing array they created? I set off on a brief, 21st-century trek to see how dogs and humans interface in the developed world. It took me from the rolling hills of the Blue Ridge in Virginia to the highlands of western Scotland, where dogs still earn their keep by hard work, with stops in between in urban centers such as New York and London, where the average dog's life is far more leisurely.

I traipsed with Scottish shepherd Roddy MacDiarmid in the pale green highlands overlooking Loch Fyne, where for his entire career he has used Border collies to round up black-faced lambs and ewes on the estate of the late John Noble. "Everywhere you look," says MacDiarmid, sweeping an arm to take in thousands of acres of high grazing land, "I have gathered sheep. And I can tell you this: You cannot gather sheep from these hills without dogs. Never could and never will. Never, never, ever!"

I stood in the Shenandoah Valley on a soft spring day, listening to the eager howls of a pack of 90 foxhounds awaiting their exercise session with Billy Dodson, huntsman for the Thornton Hill Hounds. He breeds Penn-Marydel/American foxhound mixes to chase foxes through dappled woods and fields three times a week from August to March. The rest of the year they eat and sleep in a dark, rough-hewn barn and train twice a week under Dodson's whip.

To hunt on horseback behind this well-honed pack is beyond exhilarating, said Dave Ingram, a retired banker from Culpeper, Virginia, who helps Dodson with the training. His only reward is to gallop behind, listening to a chase along a ridgetop on a crisp autumn day. "It makes the hair stand up on the back of my neck," he says.

Modern society has found plenty of other practical uses for dogs. Their keen sniffers are used by upland hunters to locate woodcock, grouse, quail, pheasants, and rabbits in the woods and fields and by waterfowlers to retrieve ducks and geese from seemingly impenetrable marshes. Dogs are put to work by law enforcement officials in the effort to block drugs, explosives, and other contraband from slipping across borders. They can track fleeing criminals, or search out the victims of their crimes.

How sensitive is a dog's nose? It's almost impossible for the human mind to comprehend. They smell things we don't even know exist, using as many as 220 million olfactory receptors, compared with just 5 to 10 million in a human nose.

At the U.S. Customs training center for drug- and currency-sniffing dogs in Front Royal, Virginia, handlers work with some 85 recruits a year, mostly Labrador retrievers. "These dogs find drugs inside propane tanks, in false-sided suitcases covered with fiberglass and Bondo, inside the wheels on roller suitcases, in driveshafts and oil pans in cars," marvels Jeff Gabel, who has worked with enforcement dogs for more than 20 years. Better yet, they never stop sniffing. Frequently, I was told, dogs scent contraband in unexpected places, well after a search has been concluded.

Dogs are used to sniff out buried victims of urban disasters such as the September 11, 2001, attacks on the World Trade Center in New York; they can locate bodies of

drowning victims underwater, or smell the minute residues of gunpowder where a shot was fired, to help police dig up evidence. They are put to more mundane purposes, too. When my son was a young lacrosse player, practicing shots in the backyard, he often overshot the goal and threw the hard rubber ball 50 yards or more into thick woods and briars. We sent our Labrador in pursuit of the seemingly odorless spheres and he rarely came back empty.

Dogs are trained to serve as eyes for the blind, ears for the deaf, and companions for the unwell. They help disabled people such as Lori O'Heron Rizzo, who lives outside Washington, D.C., with her husband and two school-age children. Her rheumatoid arthritis is so severe it forced removal of one hip, one knee, and a shoulder. Now she gets around in an electric wheelchair. Her helper dog, Banjo, trained by the nonprofit group Fidos for Freedom, follows her everywhere at a leisurely pace, picking up anything she drops or needs. Banjo helps her stand when she has to, guards her, and keeps her company when the family is away. "I'm happier with him," she says, "more confident and not so afraid of what's in the future."

But dogs that serve humans in such defined ways are just a tiny fraction of the ones who loll about, rewarding us only with loyalty and affection in the form of an unsolicited lick on the hand or the willingness to listen to our mental meanderings with the sort of attention that suggests such babbling is deeply meaningful. "Lord," the playful dog fancier's prayer goes, "make me half as smart as my dog thinks I am."

Increasingly, in a civilization circumscribed by automobiles, computers, and mass media, dogs help keep humans in contact with life's simpler pleasures. Michael Critzer, recreation planner in Montgomery County, Maryland, says the top priority of his department these days is creating designated areas in public parks for people to take their dogs to run off-leash. "Dog parks have become our biggest demand," he says, adding, "In this area, dog walking is considered the No. 1 recreational activity."

In New York, dogs' need for daily exercise coupled with the average dog owner's busy schedule has spawned a high-visibility industry as professional walkers lead packs of as many as 15 dogs along crowded city streets. It's an amazing sight, as disparate breeds weave along in strangely rhythmic harmony. The city also is home to dog-grooming emporiums, indoor day-care facilities where pets can roam off-leash with their peers, even exercise clubs for dogs.

But nowhere are the excesses of humans' infatuation more in evidence than at Crufts, the world's largest dog show, which annually takes over a 250,000-square-foot expo

The Darwin exhibit at the British Museum of Natural History, London.

center with five huge halls in Birmingham, England. Crufts annually draws up to 25,000 dogs and well over 100,000 people, who wander concrete walkways from one fake-grass showring to another till their feet grow weary, along the way filing past hundreds of booths featuring doggie gadgets and doggie knickknacks in mind-boggling profusion.

In the meantime, dogs of every description are being coddled, pampered, and gussied up for a competition that's mostly about looks. "It's called competing in breed, but really it's just a beauty show," says Caroline Kisko, a spokeswoman for Crufts who keeps busy when the show is not on caring for her brood of 21 Siberian huskies and 4 German shepherds at home in East Anglia. She uses the huskies to pull wagons in overland races, just for fun.

In her view, Crufts, the grandest convention of dogs and dog lovers on Earth, is just a big party for man's best friend. "It's good fun and the dogs love it. Thousands of people are there all day petting them; the dogs go home exhausted because normally they sleep all day."

All of which suggests that although in the early stages of the dog-human relationship man may have been calling the shots, dogs usually get the better end of the bargain now.

Biscuit, anyone?

Dogs in Our *Lives*

"The one absolutely unselfish friend that man can have in this selfish world, the one that never deserts him, the one that never proves ungrateful or treacherous is his dog."

—GEORGE GRAHAM VEST

Speech in the U.S. Senate, 1884

A young child stops in New York's Central Park to hug Priscilla, an Alaskan malamute-shepherd mix.

I was about six when I got my first dog. I named him Skippy. He was a hyperkinetic black terrier, whose main connection to his world was through barking. I think my parents bought Skippy because it was the thing to do—the station wagon, kids in the backseat, and a dog hanging its head out the window, barking at everything that came into view. But the reality was that my sister and I were at school all day, and my mother relegated poor Skippy to long stints in the basement or chained to the clothes pole in the backyard. When I was

around and not playing with my friends, I remember the routine my parents laid down for me: Feed the dog, tie the dog outside, walk the dog, put the dog in the basement, let the dog out—repeat. But because I was a child and undependable, my mom eventually took over these duties, and this did not make her happy.

As I look back, I wish my family and I had been more aware of Skippy's miserable situation. I wish I had objected to his confinement or the teasing from the neighborhood boys. I regret the times I ignored him as he looked at me, tail wagging, straining at the end of his leash. I took my dog for granted, plain and simple. Then one day while I was at school, Skippy escaped from his chain and wandered onto a busy street by our house. My dad brought home his collar, and for weeks I carried it to school stuffed into the pocket of my pants. This was one of my first lessons in life—the pain of losing someone you love, especially someone you had taken for granted. I learned what it was to lose a dog.

Now, 50 years later, I think of the sad story of my dog as the beginning of my awareness of how important and strong one's love can be for others, including canine companions. I find some solace in knowing mine is not a unique story about a boy and his dog. How many other stories like these are buried in the long and lost history of dogs? The very fact that this distant relative of the feared and mysterious wolf has found its

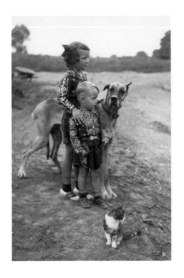

Author Richard Olsenius, his sister Donna, and Judy, his uncle Stu's Great Dane, 1949.

way into the hearts of millions upon millions of people is a remarkable story in itself, and within that history are countless untold stories of love and affection. I set out to find just a few.

I decided to go back to the very beginning, to northern Israel, along its troubled border with Lebanon and Syria. It was here in the late 1970s, near Qiryat Shemona, that a remarkable discovery was made. Archaeologists unearthed one of the earliest records of a human and a dog buried together. They estimate that this burial took place some 12,000 years before our time, during the Natufian period, an age when roaming bands of hunters were settling down and beginning to farm east of the Mediterranean.

It was a period of domestication, and it's likely that the wolflike dogs that followed the hunters finally moved within the family structure, if not into the tent or house itself. Domestication during this period must have come relatively quickly to those dogs that showed intelligence, controllability, and loyalty to their newly adopted families. For what mother or father in those times would allow a dangerous animal to roam among their children?

As I drove north from Tel Aviv toward the Golan Heights, I reflected that my quest to see this earliest and little-known evidence of canine love seemed ironic during these

Dennis Miller and his Chihuahua at Fells Point, Baltimore, Maryland.

tense times. I was met by Ammon Assaf, who heads the Houleh Museum of Pre-History at the kibbutz Maayan Baruch. "You know very few people come here now, during these days of conflict," said Assaf as he opened the locked doors to the small museum and turned on a few lights. We stopped talking as we moved to the corner. There, a small floor display encased in Plexiglas contained a human skeleton lying on its side, knees drawn up tightly.

Assaf stood quietly by as my eyes followed along the woman's outstretched arm to where it rested on a small doglike skeleton. The body language was unmistakable; she and her dog had shared a relationship that was something more than sharing a warm spot by the fire ring. Could there be another explanation as to why her family would send them on the long journey together? For two or three hours in this darkened empty museum my mind stepped back in time while I photographed the pair under small flood-lights. Staring down at them in this half-light I had no idea of the lasting effect this scene would have on me. To share the same space with this ancient person and her dog, a pair that precedes me by 12,000 years, was humbling beyond words.

It was an early Sunday morning when I arrived in New York on the long flight from Israel. In the cab from Newark to Manhattan, I watched the sun's orange glow work its

way down from the tops of the buildings. Suddenly it struck me how far I'd come from that remote hillside in Israel to a city such as New York, home to 400,000 dogs.

For a century, the urbanization of this planet has been unrelenting. In the United States, as with most other countries, the growth of our economy and population has been centered on our cities. As recently as 1950, only 29 percent of the world's population were urban dwellers. Now the UN projects that in 2050, 60 percent of the world's 8.3 billion people will live in cities. For the United States the rate of rural to urban movement is even more extreme. Over the past century, the number of urban dwellers soared from 39 percent in 1900 to 80 percent in 2000.

Our faithful dogs have journeyed with us in our move to the cities. With our jobs, schedules, long commutes, children's activities, and any number of diversions, how is it that our dogs continue to be an important part of our busy lives? An estimated 55 million dogs bed down each night in 32 percent of all homes. How can we explain the continued increase in dog ownership here and around the world?

Sociologists suggest that, encased in our cities, cars, and offices, we have been isolated from our physical world, and that our dogs provide us with a connection to something wild, something from our past that makes us crave a connection to the natural world. Dogs fulfill some of that need. Dogs have infiltrated our lives to such an extent that our emotional response to them can be as strong as to our spouse or friends, even in death.

One Sunday I checked into an uptown hotel, loaded a camera with film, and headed for Central Park. Sundays are special in New York. I had lived and worked in New York City years before and remembered how Manhattan transforms on Sunday mornings to a kinder, gentler place.

On Sixth Avenue, not far from Central Park, I stood next to a young woman who was jogging with a Siberian husky on its lead. She was running in place, waiting for the light to change. I wanted to ask her some questions, but a New York street corner is no place to try to converse with a stranger. I made a photograph instead. I watched as they ran off, and I was reminded of the time I had spent in the high Arctic, far out on the sea ice at -20°F, riding a dogsled pulled by such huskies, the kind of spitz dog that allowed the early Inuit to survive the world's harshest climate. That scene seemed light years away from this crosswalk in NYC.

Ruth Hoffman, 60, has been walking dogs professionally in Manhattan for more than 22 years. She started back in 1980, when her love of dogs and the perceived need of busy

people to get some help with their dogs jelled into a business. Many registered dogs have Upper East Side addresses or ones that border Central Park, and that's where Hoffman focused her business.

"So I began walking dogs, a few in the morning and a few in the afternoon," said Ruth, as she waited for a housekeeper to bring down a beautiful Afghan hound. Ten other dogs sat patiently at her feet. She had four more to pick up this morning.

"I now have up to 17 dogs in the morning and afternoon, and I walk about eight miles a day doing this," she said. I later calculated that she has walked about 70,000 miles over 22 years. It is no wonder Ruth looks incredibly fit. "But I'm cutting back, you know. I'm 60 now, and after all these years, these legs are beginning to feel it," she said.

Conversation abated for the next hour or so, since there is no talking to Ruth during her route. Her total concentration is on the dogs, hoping to avoid a wreck, I guess. "All right Sam, calm down," said Ruth to a yellow Lab as they made their way through the crowded Park Avenue sidewalks filled with businessmen and women. "I don't want to tell you this again, Sam, I told you to stay on the outside. OK guys, let's move it along, come on, stick together—good, that's good. Alice, please keep up, my dear." Ruth communicates almost constantly in low tones, requiring each dog to listen carefully. And they do.

"It's like the parting of the seas, isn't it?" said Ruth as we rounded a corner and headed over to Central Park. "People just get out of the way and then stop to watch the whole scene; they can't get over it." Ruth carries a bag of newspaper strips over her shoulder so she can clean up after the dogs. "That's no small task, with 17 dogs on a morning rush-hour walk through Manhattan," said Ruth, who in an effortless motion can pull a sheet of paper, bend down with 15 or more dogs in tow, and take care of business.

Ruth finishes her afternoon walk by depositing the dogs one by one with their owners or the doormen at their respective apartments. It's rather like parents picking up their kids at day care.

"So how long will you continue to do this," I asked.

"As long as I can keep up with the pack," she replied.

"Oh, doesn't she look nice," said NancyJane Loewy, resident of Manhattan's Upper East Side and owner of Tiffy, a Maltese. They had just returned from Tiffy's bimonthly grooming at an establishment named Karen's for People Plus Pets. "Some people groom their dogs every week at Karen's, but for Tiffy, this is enough," said NancyJane. "It's not really the cost that limits Tiffy's visits to the groomer, but her busy schedule only gives

Heading for a walk in the park, Birmingham, England.

us so much time. We have to go to this exclusive dog club and gym called Biscuits and Bath. Then there's professional walks I have to get her ready for, and of course there's the weekly encounter with her boyfriend, Bucky, a male Maltese who enjoys Tiffy's company. Often we go to the Bistro du Nord on 93rd Street and share a cheese-and-fruit plate or a terrace lunch at the Stanhope Hotel." NancyJane has the time and the wherewithal to take care of Tiffy.

NancyJane's Maltese hardly looks like the type to come off a Phoenician trading vessel at the Mediterranean Island of Malta 2,000 years ago but, like most of our dog breeds, the Malteses have moved far from their original home turf.

"I love my dog and I'm going to give her what I think she needs for as long as I can," said NancyJane, sitting on her red couch and stroking Tiffy. Along with dog food, she feeds Tiffy a small daily portion of carrots, rice, lamb, poached salmon, and chicken, with low-fat yogurt for dessert. To sleep all that off, Tiffy prefers the couch to her $500 dog bed. "Do I feel that is excessive?" NancyJane replied to my question. "Well wouldn't you do all that you can do for the one you love? The dogs in our lives give us a way out of ourselves, so we can focus attention on our companions and others. Tiffy is the only one that always gives back an unconditional 100 percent."

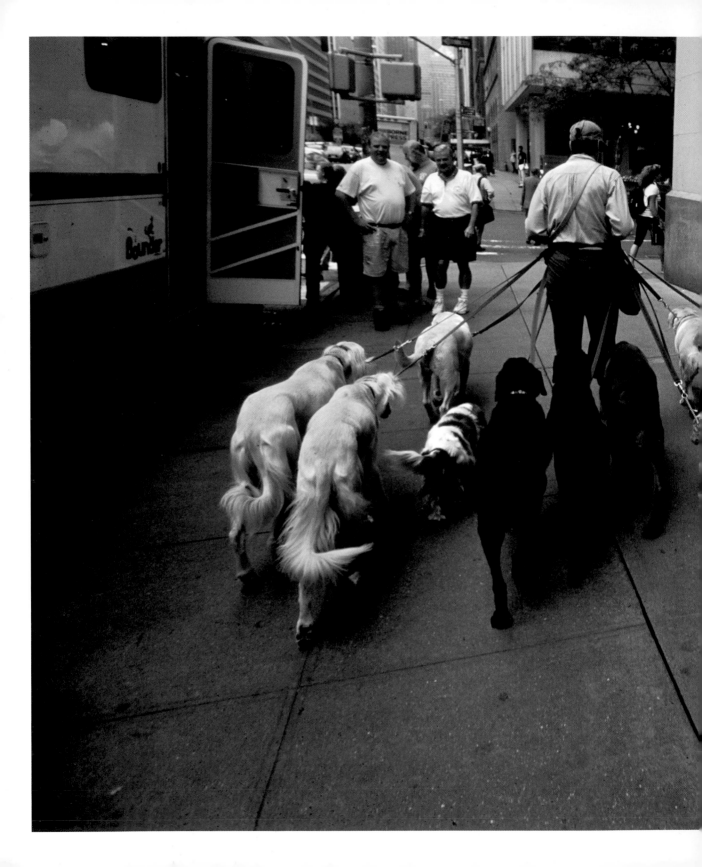

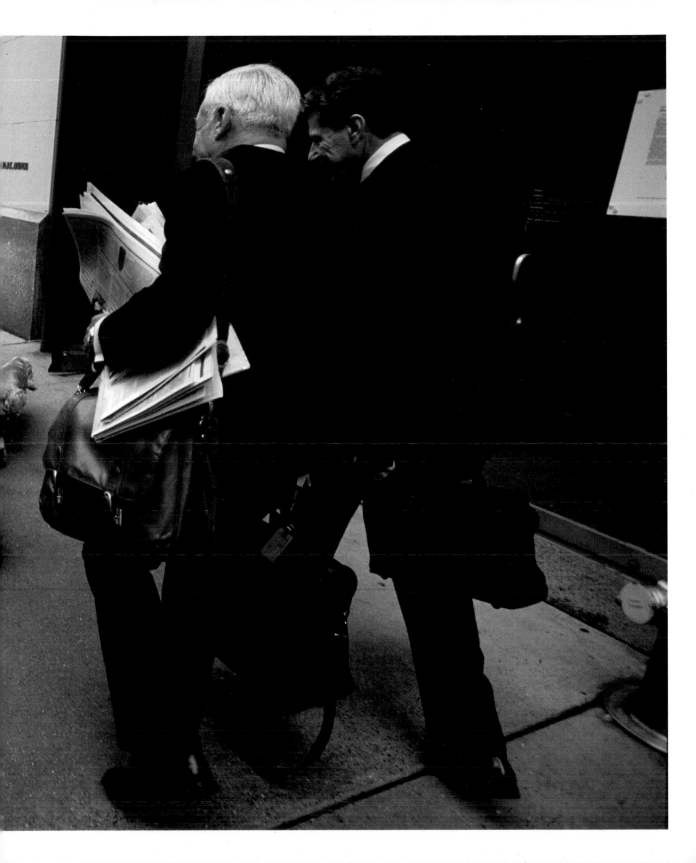

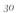

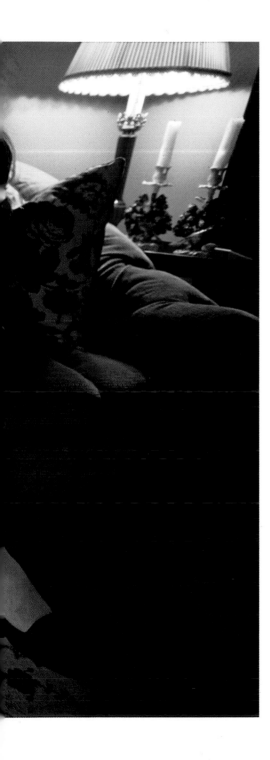

■ PRECEDING PAGES "It's like the parting of the seas," says Ruth Hoffman as she heads toward Central Park on her morning run as a professional dog walker. Hoffman figures she's walked close to 70,000 miles over her 22 years on the job. "I owe it all to Captain Jim Buck, who really began this back in the sixties when he recruited young girls in white shirts and capri pants to train as walkers for dog owners too busy to take their dogs out. I was working as an advertising account executive when I decided this would be more fun. You really have to stay focused when you're walking ten or more dogs. Having a conversation with anyone is out of the question. These dogs can sense almost all of my moves, it's really uncanny. Every day I thank God for what I've learned from my dogs."

■ LEFT "Why wouldn't I want to give everything I can to my Tiffy," said NancyJane Loewy about her Maltese as we sat in her Upper East Side apartment. "It's so simple. Why, with all the mistreated animals in the world, wouldn't you give the same love and care to your dog as you would your family? You can tell how people treat each other by the way they treat their dogs. I don't just love Tiffy, I love all the dogs that come to my house, and that includes Bucky, Bobby Blue, Freddie, Fergie, and Tucker, to name a few."

"Do you mind if I take some pictures?" I asked.

"No, go ahead, we love to have people take their pictures," said Nicky Miritello. "We come into New York several times a year just to do this, meet people and walk in the park." I thought how ironic it was to come to New York City to meet people. But it was quite astonishing to see how many people stopped to pet the dogs and talk to the Miritellos.

"So what kinda dog is that," said a young man with layers of huge gold chains hanging around his neck.

"Shepherd mix," said Nicky.

"Well they're real nice. You know I had two dogs, but I had to give them up. I'm gonna get me another one, though. I really miss them," he said, kneeling down to stroke Presley. An older woman, bent with osteoporosis, stopped to pet the dogs. She became animated and made instant friends with the two dogs.

"This happens all the time," said Nicky. "We just love it, and the dogs love it too. I don't know what this is all about, but people love dogs, especially big fluffy ones."

OPPOSITE Afternoon walkers at New York's Guggenheim Museum.

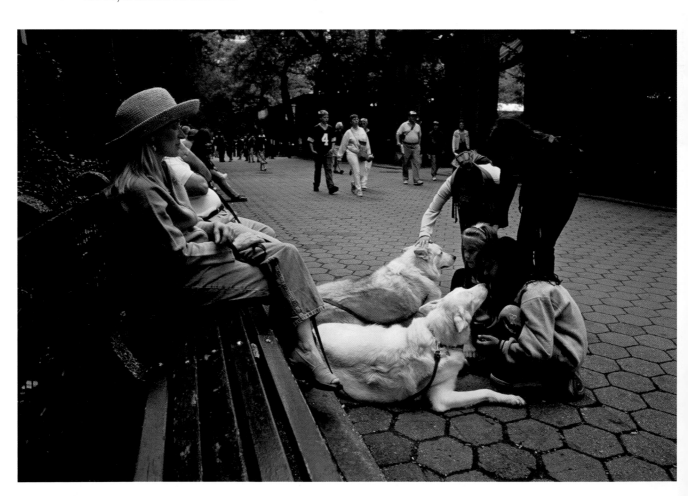

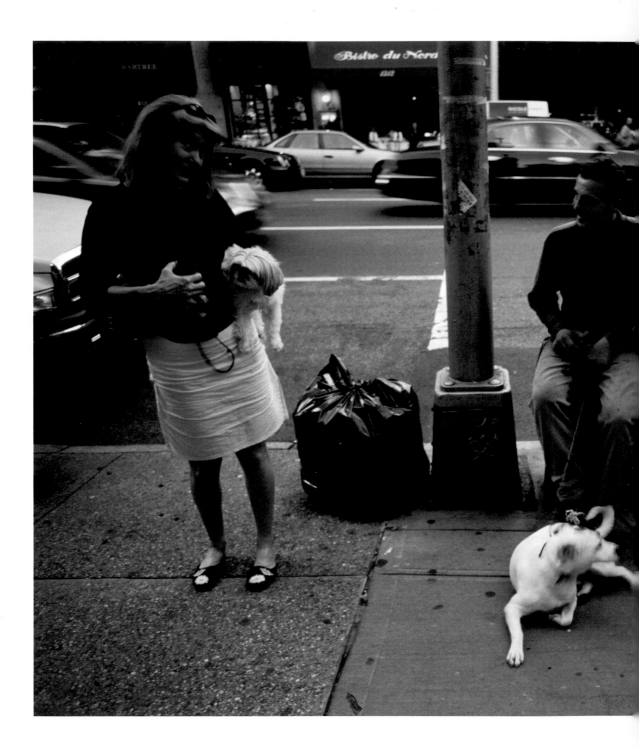

■ His name is Wayne, and he calls his dog Lucy. He's a homeless man who prefers to hang out in New York's Upper East Side. "I couldn't make it without Lucy," said Wayne, standing up and tying Lucy to the cart containing his belongings. "I'd be just another homeless face in the crowd, but with Lucy, people stop to talk and give her and me food. I know many of the people along here and they want to help me out; I'm thankful for their help." Wayne seemed a little uncomfortable answering my questions, but I wanted to find out more about his dog.

"I was walking along the expressway one night when this car goes by and throws this dog out the window. She was really banged up, but I picked her up and took care of her, and she's been with me now for five years," said Wayne as he gathered up the dog and prepared to leave. "We've been together ever since. Some people might see this as an act, but this ain't no act — the two of us need each other to get by. I know the times when I'd sit on a bench all day and nobody would look at me. Lucy has saved me and I saved her, it's that easy."

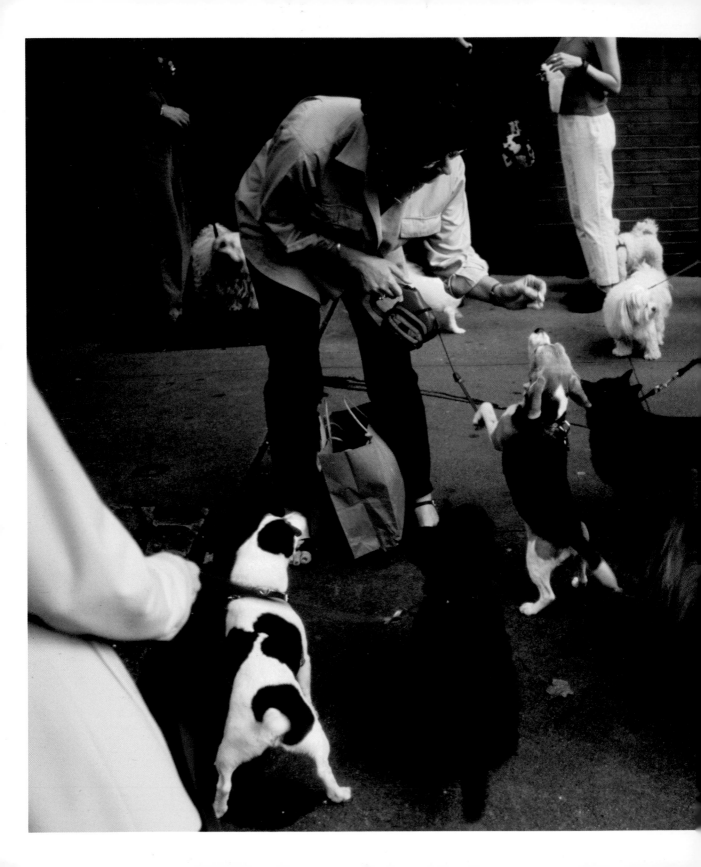

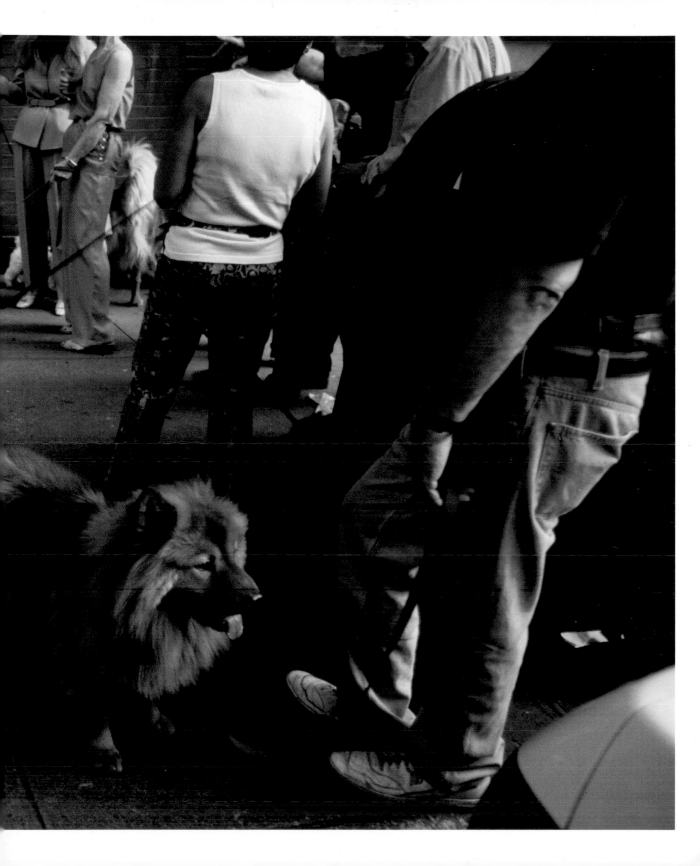

■ **PRECEDING PAGES** "Do dogs make a difference in people's lives?" I asked Lenny Golay, one of the owners of the Corner Bookstore. She and her partner, Roy Sherman, have hosted a neighborhood "Doggie Buffet" party for 14 years to help raise money for dogs abandoned in Central Park.

"Sure they make a difference," she replied. "Our dogs bring us together; it's sort of a common ground that helps break the ice and connect us here in the city. Look at the hundred people standing around laughing and untangling leashes," she said.

■ Kell, an English mastiff owned by Tom Scott, from East Leake, England, holds the world heavyweight record at 286 pounds. "She was kinda scrawny at first," said Scott, "but she kept eating and wouldn't stop. I mostly feed her 15 pounds of raw meat a day. Kell is really in the mood for love now, but it's going to be hard to find her a mate. We need to hurry; she won't be in the mood for long."

■ **OPPOSITE** "Nellie's a real actor when it comes to getting in the house," said Sandra Cartwright-Brown, of Sperryville, Virginia. "She'll fake a shiver in May, just to get me to open the door."

■ "His name is Duba," said Benjamin Marcino of his Neapolitan mastiff. "Sure we love to romp and swim, but I usually come back from our trips to the beach with claw marks all over me. He loves the freshwater shower the most." The mastiff probably made it into Italy by trailing after Alexander the Great from Greece and Asia. The Romans bred huge war dogs, and the Neapolitan mastiff most likely descended from those. "My dog is a lover, not a fighter," said Marcino, who runs a clothing store in Tel Aviv. "This dog really attracts women and that's how I find my models."

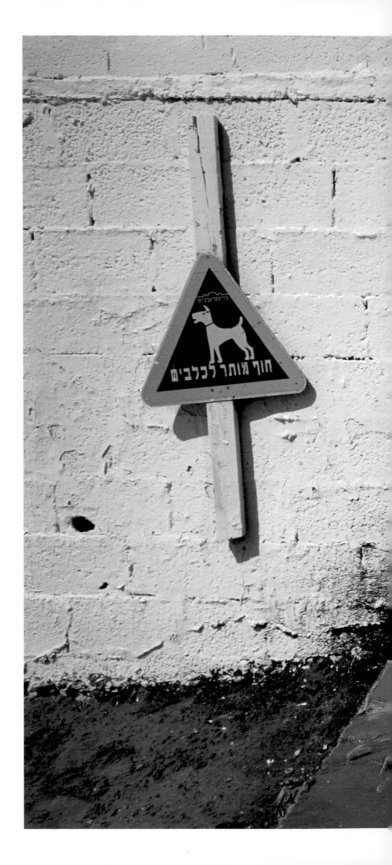

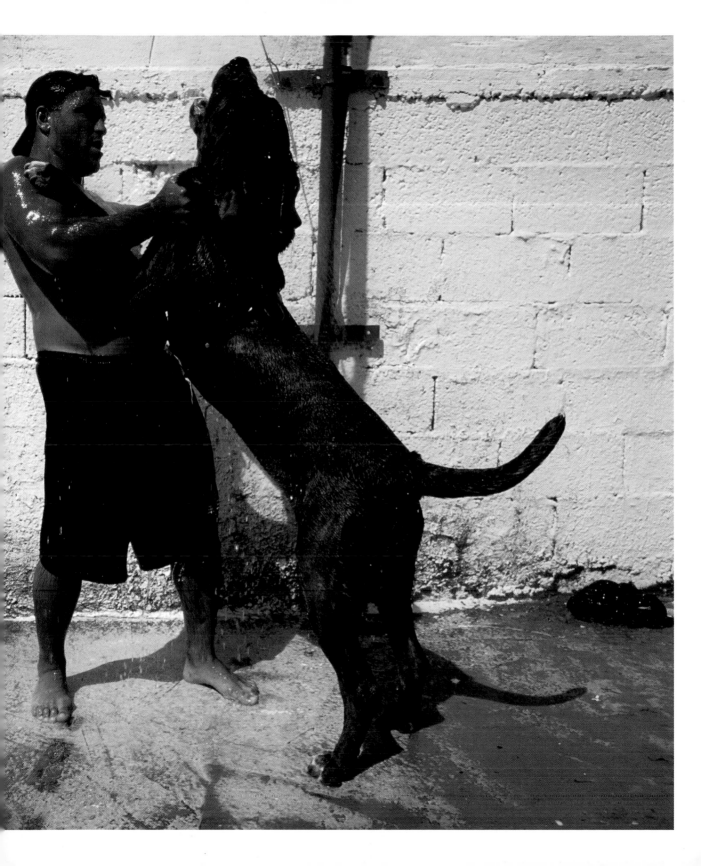

42 ■ Moshe Diamond, his wife, and Ring, their shar-pei, spend a Sunday afternoon at Tel Aviv's designated dog beach on the Mediterranean. "This is a great place," said Diamond. "Ring can watch all the other dogs and we can relax without someone coming up and telling us our dog is a bother. It's always packed too. I'm always amazed how people want to come and play with their dogs. I think it's a big excuse to be a kid again. I know for the most part these people will live longer, because they're having too much fun."

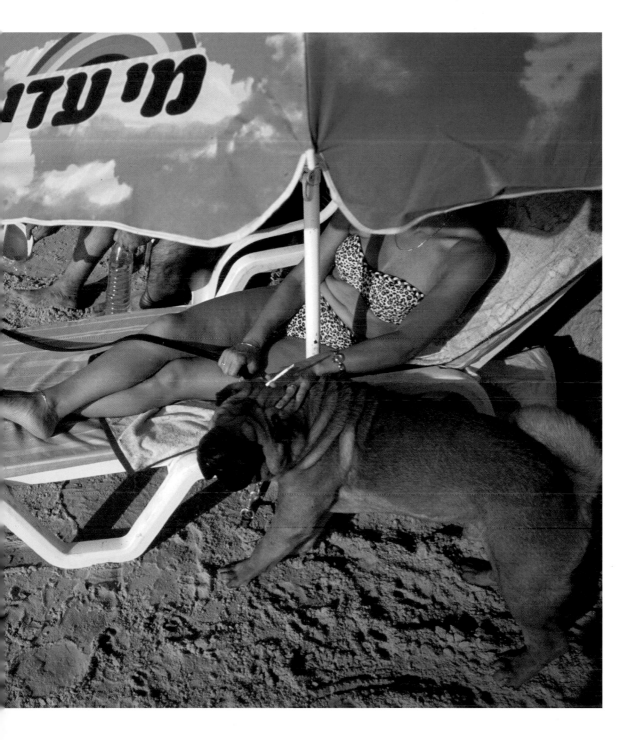

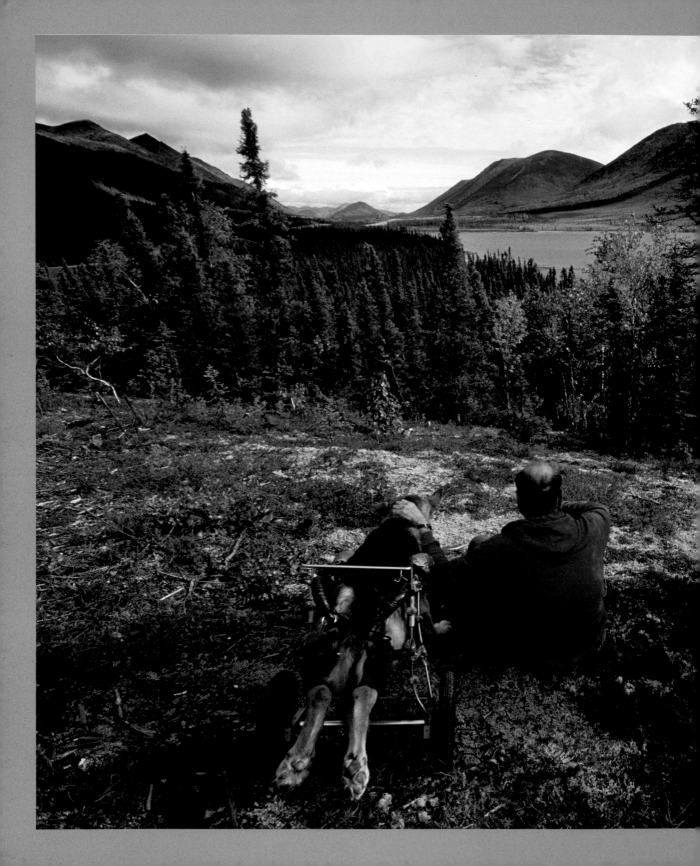

One Last
Road Trip

"My life with my dog, Sonntag, changed dramatically one afternoon in 1998, when I was playing ball with him." said Ed Mulrenin as we sat on a moss-covered hill overlooking Grayling Lake, just south of Alaska's Brooks Range. "He went up after the ball like he has hundreds of times, and this one time, well, he's never been the same. Doctors said he had snapped a vertebra. The bottom line was Sonntag became paralyzed in his hindquarters and could not walk.

"My God, I tried everything—surgery, acupuncture, steroids, and even water therapy. I probably spent over $20,000 to bring him back. Most people would have put their dog down at this point, but Sonntag still had his spirit, and when he would look up at me I told him we were in it for the long run. He had added so much to my life for ten years, now it was my time to give back to him. I had this special wheelchair made, and I estimated one day that 18,000 people had stopped to ask me about the 'wheelchair dog.' There was only one who said I should put the dog down. These last couple of years began to wear on Sonntag, and it was getting more difficult for him go through the routine of getting in and out of the chair. The summers were too hot in Washington, so I decided to take him for our greatest ride.

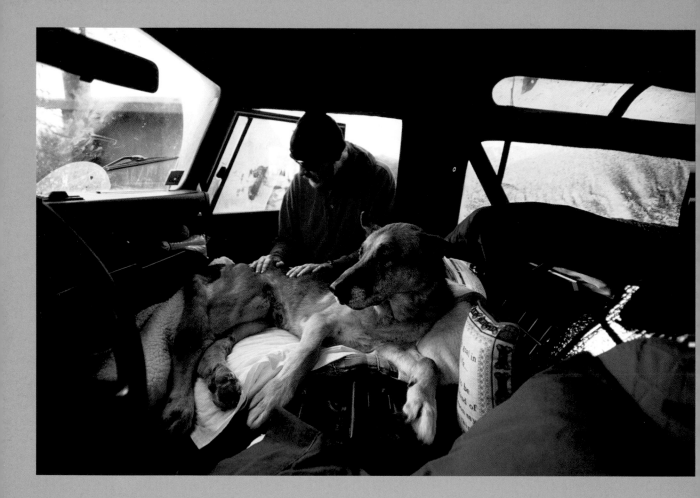

"I figured out that the longest road trip from Washington, D.C., was to Prudhoe Bay, on the north coast of Alaska," said Mulrenin as he adjusted the special seat he had built into his Land Rover for Sonntag. "So that was it, a 12,500-mile round-trip, just me and my dog. Even though Sonntag loved to ride in the car, I wrote down a number of ground rules so he and I would never cross to where neither of us wanted to be. His comfort and enjoyment were always at the top of the list."

I had joined Ed and Sonntag in Fairbanks, Alaska, for the last rugged 400 miles of gravel road to the Arctic Ocean. During these long days of driving, I watched as Ed pulled over to the side of the road every couple of hours and lifted the 80-pound Sonntag into his chair for a walk. "Sonntag needs help to go to the bathroom," said Ed. "He also has to be exercised regularly, and I have to keep him as active as possible so he doesn't get any sores. Lots of people ask me, 'How do you keep his spirits up, since he's confined to a wheelchair?' The answer is simple: Do everything you'd do if he were whole. People were amazed when I had special skis made for his chair one winter."

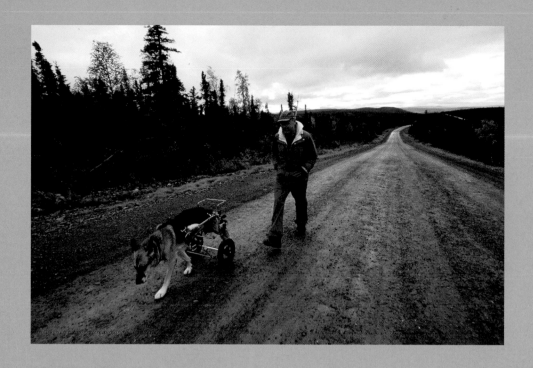

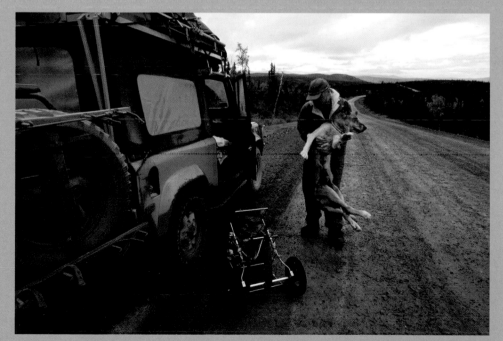

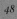

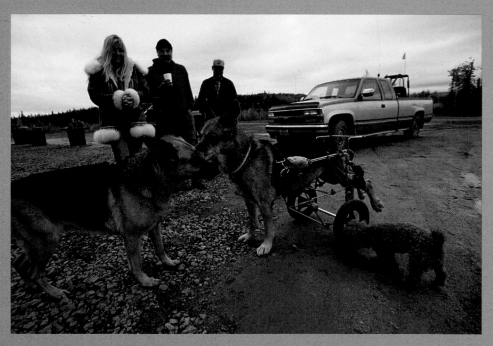

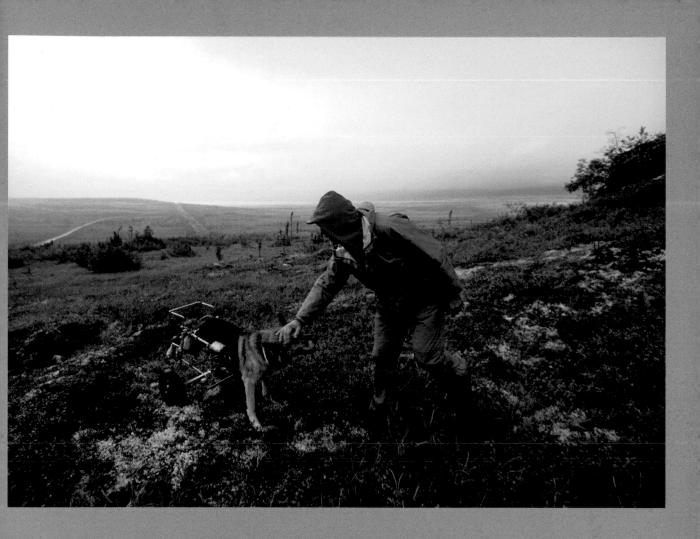

For the next few days Ed, Sonntag, and I camped, hiked, and drove through the Alaska wilderness. I remember reaching a small café called the Hot Spot, where we stopped for a burger. The local dogs had to come out and sniff Sonntag's tires. As usual, Sonntag was a spectacle. Later, as Ed picked out a camping spot on a hillside overlooking a vast Alaska plain, I thought how fortunate I was to witness the unconditional love shared by these two. I still find no adequate way to describe the relationship between Mulrenin and his dog.

On the evening of the third day, a snowstorm blew down from the North Slope of the Brooks Range, covering us with thick wet snow. In the morning's fresh snow, Sonntag and Ed paused to look over this grand landscape. "It's time to break camp, Sonntag, and head home," said Ed. "You got what I promised you."

Mulrenin didn't grow up with dogs; it was only later in life that he discovered the value of having a dog. "This is my third shepherd, but Sonntag forced on me a responsibility that I never expected. Sure, 98 percent would have put their dog down, so I guess in a way I've raised the bar for what one would do for their dog."

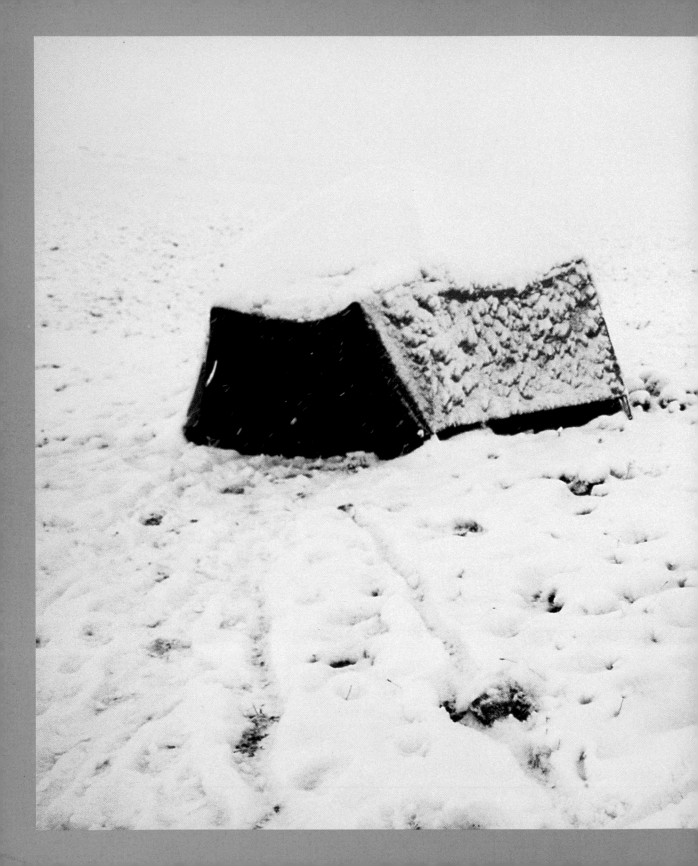

At a small turnout along the Dalton Highway marking the latitude of the Arctic Circle, Ed pulled over and got Sonntag into his wheelchair for a photograph. "For the last 14 years I've been with this guy, and this final chapter has showed me how to define what is important, how to take a negative and make it a positive. Did this make me a better person? I don't know, but I do know there are few life experiences such as this, and it has helped me to know what's the right thing to do.

In Washington a few months later, there were mornings when Sonntag was having difficulty getting up. "I could see he was failing," said Mulrenin, "and I decided to close the book. We had reached the finish line, and I think that a dog like Sonntag knows I love him enough that he trusts me to do what's right for him." Ed called me to come over the next morning, when he decided to end Sonntag's life. Ed and I cried. "I will never forget you," whispered Ed, his face buried in Sonntag's soft hair. "We made it, buddy, we made it."

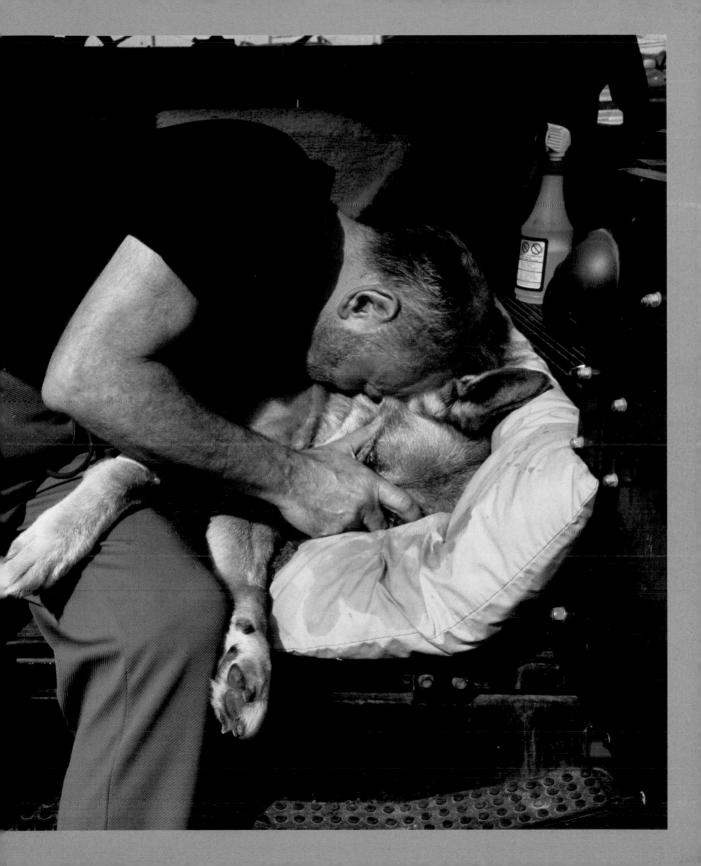

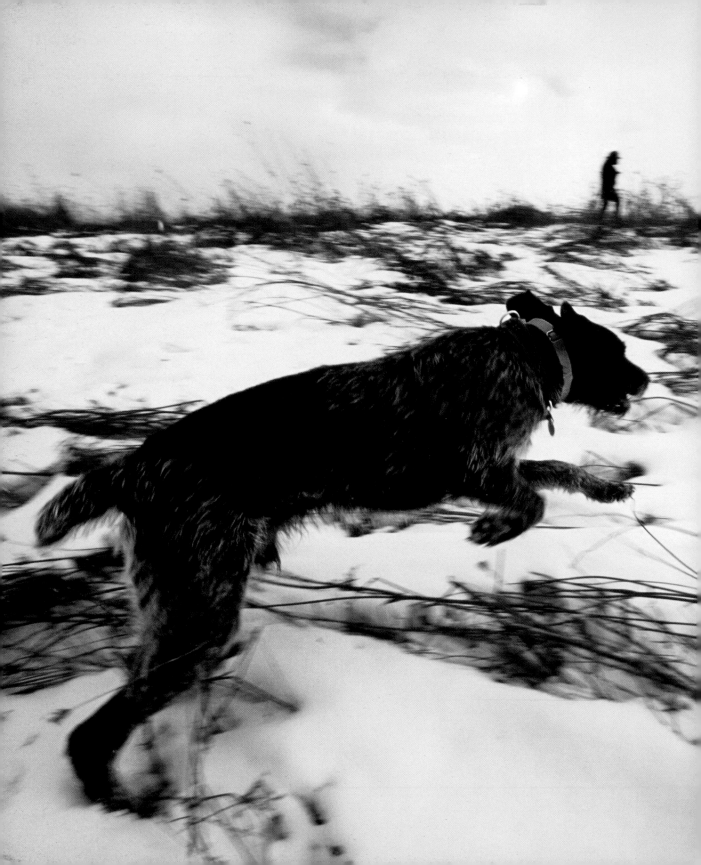

Dogs that Work

"A dog will look at you as if to say, 'What do you want

me to do for you? I'll do anything for you.' Whether a dog

can, in fact, do anything for you if you don't have sheep

is another matter. The dog is willing."

—ROY BLOUNT, JR.

1989

A wirehaired pointing griffon undergoes training in a Michigan field.

Not too many years ago I was in the Arctic, riding a dogsled pulled by ten Alaskan malamutes. An Inuit hunter named Walter was heading out to the sea ice from Holman, Victoria Island, to retrieve a broken snowmobile, and he allowed me to ride along. Walter was proud of his dogs and proud to help revive this ancient working relationship between man and dog. It was a cold, blue-sky day when we left, and by the time we found the snow-caked machine, we'd traveled almost 13 miles. Walter tried replacing some parts, with no luck.

After an hour or so, we loaded the machine on the sled. As we headed back toward the village, it was evident that the dogs were working too hard. Walter dumped the heavy load, and I could tell he was becoming concerned about the strong wind. I think his concern was mainly for me, since I had lost most of the feeling in my feet. I could only sit quietly, hoping Walter and his dogs would get us home. As the miles ticked by, I thought of ages past, when working dogs such as these were the norm and not the exception.

The original function of many types of dogs has evolved drastically over time. Thousands of years ago, for example, Afghan hounds were valued in the hills of Afghanistan for their keen sight and long-winded speed in chasing down the desert fox and gazelle. Today you can see them on fashion runways, accompanying supermodels. Dachshunds, with their short legs and long, narrow torsos, were once employed by European hunters to crawl into the lairs of groundhogs and hares. Labradors and golden retrievers were bred in Great Britain for their water skills and retrieving skills long before they became popular as suburban house dogs. Unfortunately, many working breeds such as these are now at risk of losing their natural working and hunting instincts.

In a snow-covered cornfield just outside Lansing, Michigan, I walked with hunters Jim Seibold and John Anderson, who were training their wirehaired pointing griffons.

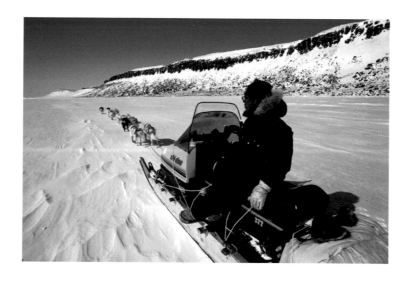

Walter Olifie and his dog team retrieve a disabled snowmobile on Amundsen Gulf, N.W.I.

The griffon was one of the first European gun dogs to be formally recognized in the United States. Over the years these dogs, as a result of various breeding programs, seemed to be losing their hunting skills. By the 1970s, the Wirehaired Pointing Griffon Club of America came to an important decision. Though it would cost them their affiliation within the American Kennel Club, they decided to go back to Europe and outcross the griffon with a similar breed, the Cesky Fousek, a Czech pointer. They hoped that the Cesky Fousek, which had retained its hunting instincts, would bring new blood to the wirehaired pointing griffon and revive its hunting instincts.

"The results have been fantastic," said Seibold, "I've made two trips to Czechoslovakia to breed my dogs and now I can see from the offspring what we've regained— a dog that naturally loves to hunt."

The Wirehaired Pointing Griffon Club exemplifies how passionate some dog owners are about maintaining their breed's genetic traits. "One cannot own a griffon without answering one question," said Seibold: "Are you dedicated to hunting with your dog?" The club's breeding committee must evaluate each dog before breeding it, and it must pass a series of hunting tests that make certain the genetic heritage stays on track.

Pure breeding is what registered dog breeders strive for. Unfortunately, with

extensive breeding among a limited gene pool, genetic problems can materialize and affect the dogs' health. Hip dysplasia may affect German shepherds and golden retrievers, and retinal atrophy may cause blindness in Irish setters. There are hundreds of hereditary dog disorders that can be traced back to overbreeding within a narrow gene pool.

The recent deciphering of the human genome should help our understanding of the dog's genetic code because of its similarity to ours. The possibility of searching out and curing a number of single-gene diseases that plague our pure breeds is within reach. The AKC, encouraged by this potential, now contributes substantial sums to genome research through its recently formed Canine Health Foundation.

As civilizations evolved over millennia, the dog's ability to adapt guaranteed its spot alongside its master. It effectively made the leap from feared hunter to lapdog. Though the vast majority of our dogs no longer use their 1.5 billion olfactory (nasal) sensors to catch the scent of a deer, our new world realities are drawing many dogs into new job descriptions. Today, dogs are being trained in airport security, land mine detection, explosives sniffing, arson and drug detection, tracking, and search-and-rescue work. A number of countries are enlisting dogs—the Beagle Brigade of the U.S. Department of Agriculture, for example—to protect their borders against the illegal entry of meat and plants, which, according to USDA, still creates more than $140 billion in losses from plant and animal diseases each year.

Twenty miles to the north of Tel Aviv, it was training night for a canine search-and-rescue squad attached to the Israeli Defense Force. The weekly training program is necessary to maintain the dogs at a high level of readiness and training and to keep their awareness high for when they may be called upon, which happens frequently. Tonight we were gathered at a demolished building consisting of giant slabs of concrete and jagged edges with twisted metal rods. The conditions were similar to what would exist after an explosion, and they were dangerous for both dogs and handlers.

"The dogs have to be constantly trained and tested," said Filo Leon, coordinator of the search-and-rescue unit. "It has to be a game, something that challenges them, and there must always be a reward at the end, like finding someone alive."

They were trying out some newer dogs, ones that hadn't quite figured out what this is all about. It is an important step, because a dog that doesn't show an early aptitude for the work is quickly dropped. A strong-shouldered German pointer was brought out first.

"We hold him to the side, where he can't watch, while one of our soldiers crawls deep inside the wreckage," said Filo. "The dogs are released and encouraged to go up and

find something, anything. But if they're smart and start picking up a human scent but can't see him or her, well that's when they get challenged, and their knack for working out the problem shows their potential."

Eventually the pointer picked up a scent and focused on the dark hole in which a young Israeli soldier was hiding. The dog crawled in to an outstretched hand and was immediately given treats and generous amounts of hugs and pats for reinforcement.

Recently a softer, gentler side of the dog has found its way into our lives. Dog owners have always known that no matter how bad their day has been, spending some time with their dog will heal most of the day's wounds. Only recently have the therapeutic powers of the dog extended beyond its family circle to therapy and assistance programs for the sick and handicapped.

At first there was only anecdotal evidence that dogs can help us cope with life. The skeptics were many. Eventually, statistical studies began to show measurable therapeutic improvements through the use of dogs. One recent Mississippi study showed that the loneliness of long-term-care residents is reduced significantly by as little as a 30-minute visit with a dog each week.

In the past decade, the number of professional organizations devoted to the human-animal bond has burgeoned. Organizations such as the Seattle-based Delta Society and Therapy Dogs International of New Jersey have dedicated themselves to improving the health, quality of life, and independence of humans through the training and use of service and therapy dogs. Other encounters between dogs and patients are finding their way into brain- and spinal-cord-injury units, psychiatric wards, burn units, and heart units such as the UCLA Medical Center. The Delta Society estimates that it has more than 4,500 pet partners that have interacted with 350,000 patients in 46 states.

Innovative ways to put dogs to work keep surfacing. Sandi Martin, a nurse, came to Utah's Intermountain Therapy Animals in 1999 with the idea of using dogs to help children with reading disabilities. "We are doing so many things with our dogs, but we were just blown away by this idea," said Kathy Klotz, director. "We have left the pilot program stage and are now working with 40 teams at 16 locations." Klotz went on to explain that it's not unusual for a child to jump two or three reading levels in a year. "It's something to see a child curled up on the floor reading to a new friend," she said.

"The dogs are nonjudgmental when the children read to them, and dogs don't laugh if a child stutters or trips over a word. That seems to make a difference to the kids,"

said Klotz. "They are more relaxed and have a more positive attitude toward the work they need to do. The improvements are measurable."

On a cold December evening I came to visit the Children's House at Johns Hopkins, in Baltimore. The Children's House is a residence, a comfortable, homelike setting for children and their parents to live in while the children undergo serious, long-term treatments. I was there to meet Linda Solano, a member of the National Capital Therapy Dogs, who visits the children at least once a week with her dogs.

"As nice as the Children's House is, the days and weeks can drag on," said Solano, "But when we visit with the dogs each week, the kids really pick up. I can see it in their eyes, and this even helps release some of the stress building up in the parents. Many of the children have pets at home, and seeing our dogs reminds them of what they have at home. It helps give them something to work for and to make their stay here more natural."

Tonight was the Christmas party, and Solano, with several other members of the National Capital Therapy group came with dogs ranging from a whippet to a Great Dane adorned with reindeer antlers. The atmosphere was festive, with the Christmas tree lights on and the kids petting and hugging the dogs and the parents joining the laughter.

"My dog Jessie can sense when someone is sick," said Solano. "She surrenders all control to the patient during the visit. The children also feel the dog accepts them as they are, not sick or incomplete as they might feel about themselves."

Most of us take for granted turning on lights, picking up keys, or listening for the doorbell, but many thousands of people have lost the use of their eyes or limbs through accidents and illness. Although dogs have been trained to assist the sight-impaired for years, assistance dogs are now being trained to take an active role helping those who are confined to wheelchairs or have other serious disabilities.

The Assistance Dog Institute, located in Rohnert Park, north of San Francisco, trains assistance dogs for people confined to wheelchairs. Their program offers a unique approach in assistance training: In a cooperative effort with the Sierra Youth Center, a low-risk detention center for kids who've had run-ins with the law, ADI is using a number of the juveniles to help train their golden retriever assistance dogs.

"We've found that kids with problems were in a shell that was hard to penetrate. Many were unreachable," said Bonnie Bergin, director of the institute. "We worked out an arrangement with the correctional facility, and now the kids help us train about 75 assistance dogs a year," added Jorjan Powers, communications director for the institute. "This experience does draw them out and has an impact on their lives. It gives them a

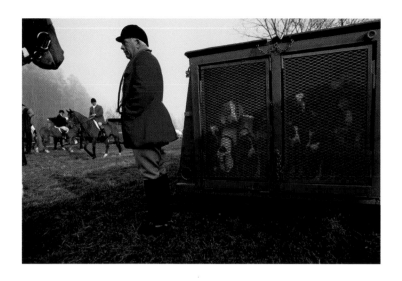

Huntsman Billy Dodson prepares to release the hounds in Sperryville, Virginia.

goal to train their dog, something other than focusing on themselves and their problems."

"Hi, girl, how you doing? You OK this morning?" said Tom, a 17-year-old from Santa Rosa. Tom, who had been quiet and indifferent when he entered the building, was suddenly down on the floor hugging and stroking the golden retriever he was training.

"OK, I want everyone to get in their wheelchairs and start going in a circle," said one of the trainers. "Good, don't let them get distracted, keep their focus on pulling you. That's good, Melissa, give Pierce some encouragement."

These lessons go on every morning: teaching the dogs to pick up keys, turn on lights, and rest alongside the wheelchair on command. During breaks the kids and dogs relaxed together. After the morning session was finished I followed the kids back to their main cottage, where they got ready for lunch. Melissa was allowed to bring Pierce back to her room.

"From time to time they let us have the dogs overnight," said Melissa, "but today is my last day here and this is my good-bye to Pierce," she said while petting Pierce gently. "You know, I think Pierce is the first time I've ever really loved something or somebody. I'm gonna really miss him."

I've been told that Melissa has been back to the detention center several times, but only to visit the staff and dogs.

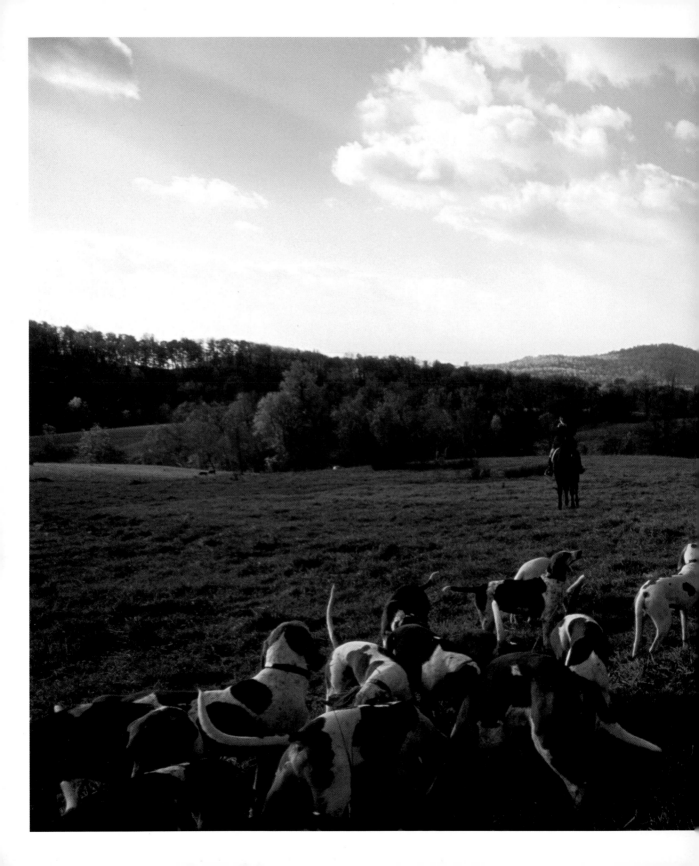

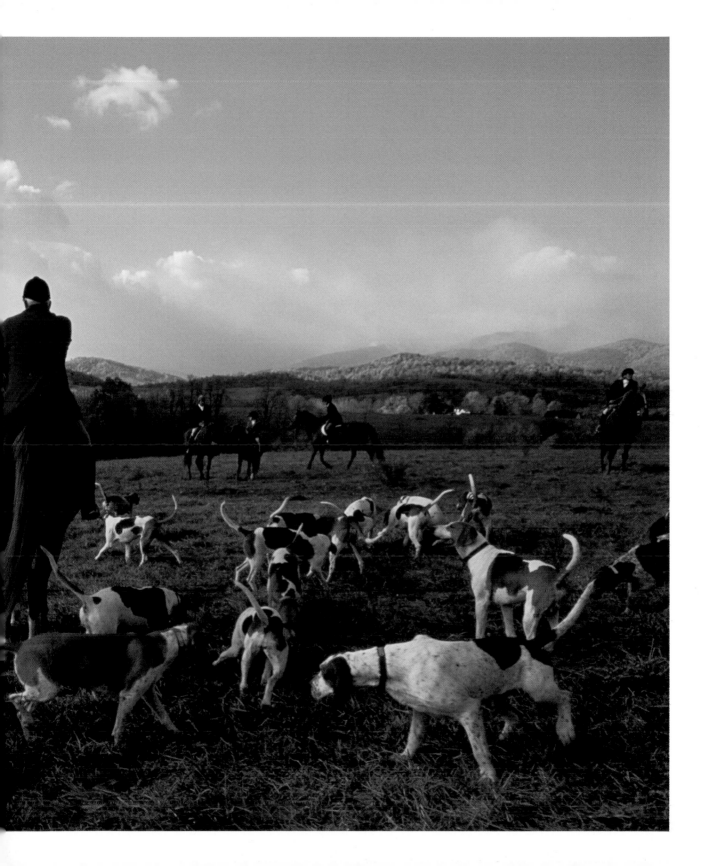

It was early morning along the eastern foothills of the Blue Ridge Mountains, not far from Sperryville, Virginia, where the fox hunting club called the Thornton Hill Hounds was gathering for a Sunday morning hunt. Smoke from some small fires burning in the distance cast a warm glow across the picturesque landscape. The hounds, a collection of American foxhounds and Penn-Marydel hounds, had just been released by Billy Dodson, huntsman for the club, and were finishing their ritual of marking the ground and taking care of business before the pack was called for the chase. "There's been fox hunting up in this country for years," said Susie Poole, one of the dedicated riders on the hunt. "It's a tradition that came from England and has a long history in this part of Virginia. But this tradition is important to me; I feel so alive when I ride, it's what these horses and hounds were bred for, to work together. You never know what's going to happen, and this unpredictability in this predictable world is what works for me."

64

RIGHT "I've been with hounds for most of my life," said Dodson as he helped load the tired pack into the trailer for the short ride to the kennels. "Things are changing here, the farms are getting broken up and people are more difficult about us riding across their land. I don't know how long it will continue."

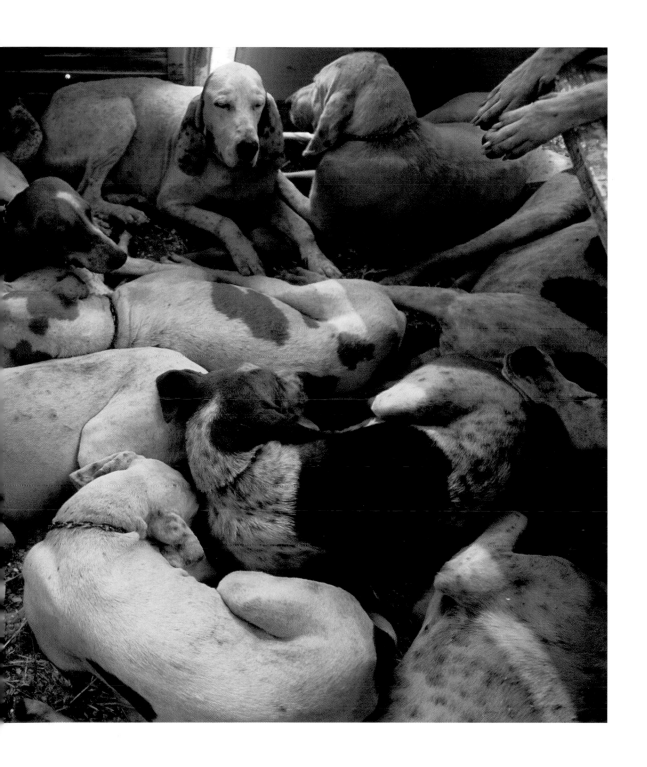

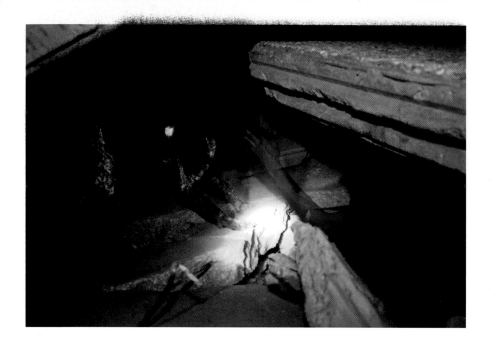

 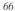 The success of the dog as humankind's companion is based on its ability to adapt to a changing environment. Where dogs once lived as opportunistic predators, they now share the city sidewalks. The need to have our dogs follow scents in hunting has diminished, but today's world has found another use for their amazing sense of smell. A dog's ability to register even the faintest scent has led it into support services we wouldn't have dreamed of just a decade ago. Search-and-rescue teams such as the elite Israel Defense Force canine unit trains constantly for the harsh realities of this new age. Bomb-sniffing dogs patrol airports around the world, and dogs are being used for the delicate work of land mine detection and drug detection. Some researchers have had success in training dogs to detect certain types of cancer.

■ "Jacques has got to have his breaks," said Melanie Smiley, a U.S. Department of Agriculture officer assigned to the Beagle Brigade. Melanie and Jacques were working at the U.S. Postal Facility at Miami's International Airport. "He ends up walking the conveyor belt, sniffing boxes and mail coming in from around the world, but for Jacques this has to be a game. I have to plant a box with contraband in it for him to find or he gets tired of this pretty fast." The Beagle Brigade's purpose is to provide a frontline defense at airports and mail facilities against banned fruits, plants, and meat. "Sure, people at the airports think the beagles are cute as they sniff the suitcases," said Smiley, "but most don't realize these dogs save us billions of dollars a year from infected food and plants." What's the worst she's seen? "One of the worst ones were the giant snails that were still alive. You wouldn't believe what people send and how the beagle can sniff through cardboard, plastic, and all sorts of wrap. Beagles are chosen," said Smiley, "because of their acute sense of smell, 40 times greater than that of a human, and they have a natural curiosity and also are good around people."

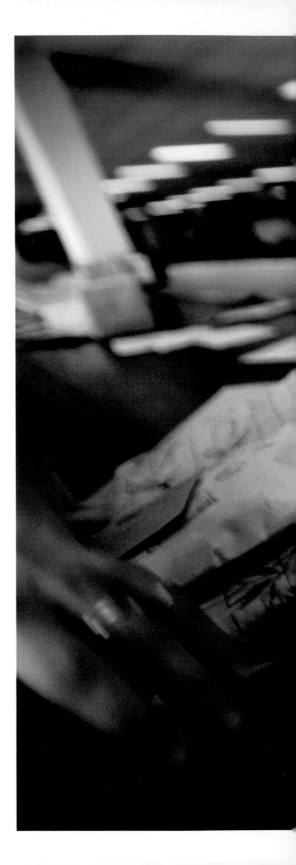

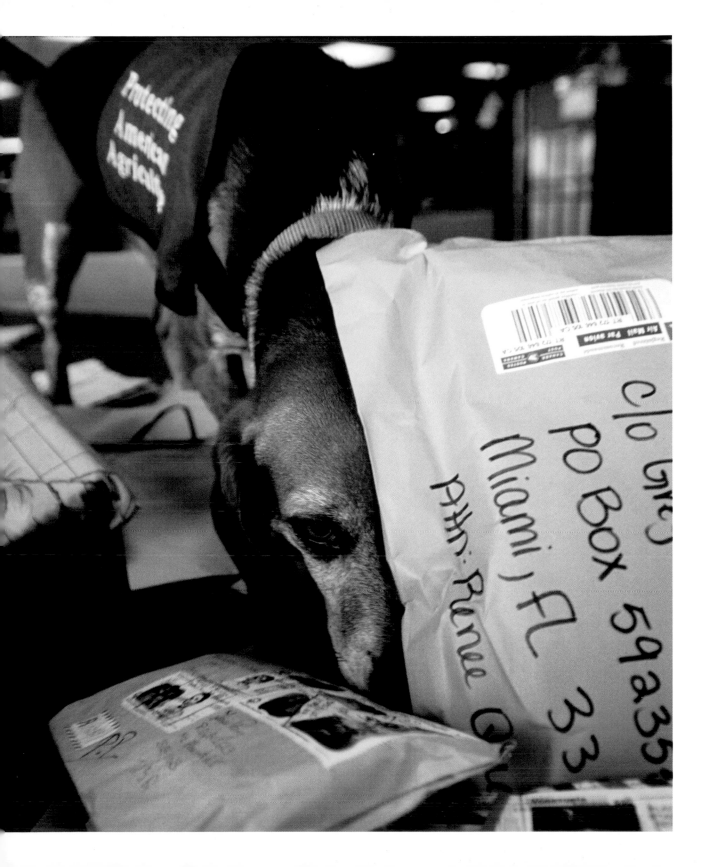

■ "I got tired of driving tugs in Vancouver, and because of some money and women problems I decided to head for northern British Columbia," said Trapper Ray. "I began by running a trapline with my dogs near Liard River Hot Springs, along the Alcan Highway, and it was quite a life," said Ray, stretching a beaver hide while his two Alaskan malamutes looked on. "Fur prices went to pieces, and so I began building up my lodge here by the hot springs hoping to get some tourists. My dogs sure worked for me, and they're always there for me regardless of how blue I get during those long winter nights."

■ RIGHT During a snowstorm near Dawson City, Yukon, a Siberian husky from Mac McLeod's team rests during a mandatory 36-hour stop on the grueling 1,000-mile Yukon Quest dogsled race.

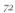

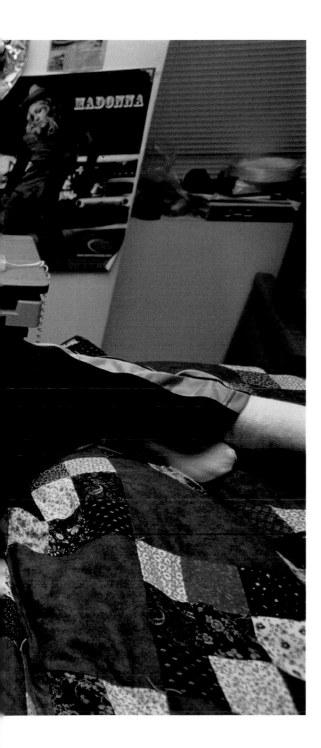

■ "It's really great when they bring the dogs to see me," said Lucas Parks, whose numerous trips to the National Institutes of Health (NIH) near Washington for treatment have become tiring. "I've seen the difference dogs can make," said Linda Solano, a member of the National Capital Therapy Dogs, who brings her whippet Jessie to NIH and Children's House at Johns Hopkins in Baltimore on a weekly basis. It takes a tremendous amount of time to prepare the dogs, and I'm thankful I have the time and the support of my family," she said. "But the rewards are worth it when you see the smiles on the children's faces. You know, these children have lost their self-confidence when they are sick, and a dog accepts them as they are. They don't have to explain to the dog about anything. Jessie, my whippet, is remarkable in that she can sense when someone is sick; she surrenders all control, like to Lucas here. The magic doesn't happen every time, but when it does, the experience carries you for the next six months."

After 15 minutes or so, it was time for Lucas to say good-bye to Jessie. "I'll see you next time, OK, Jessie?" said Lucas with a smile.

73

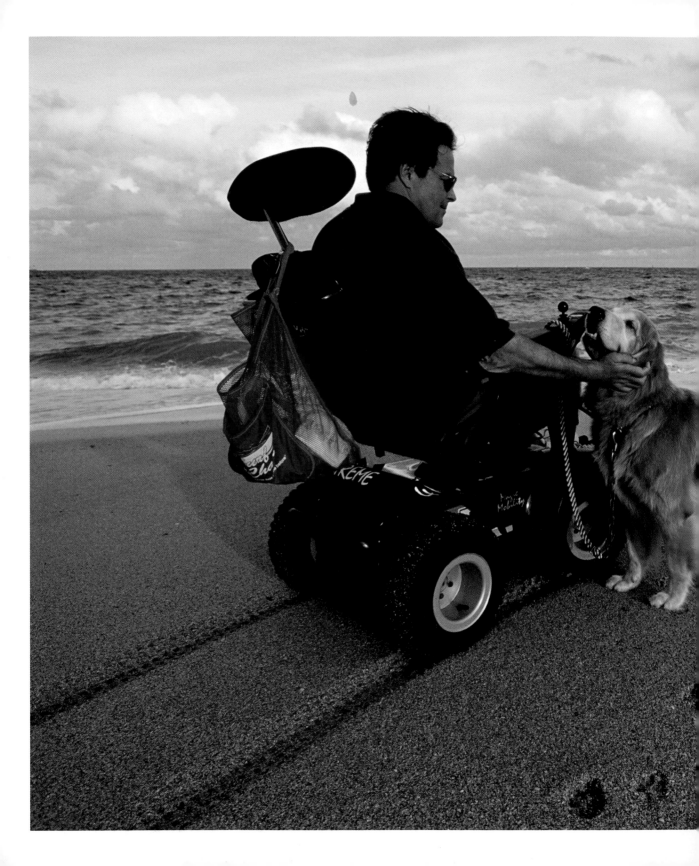

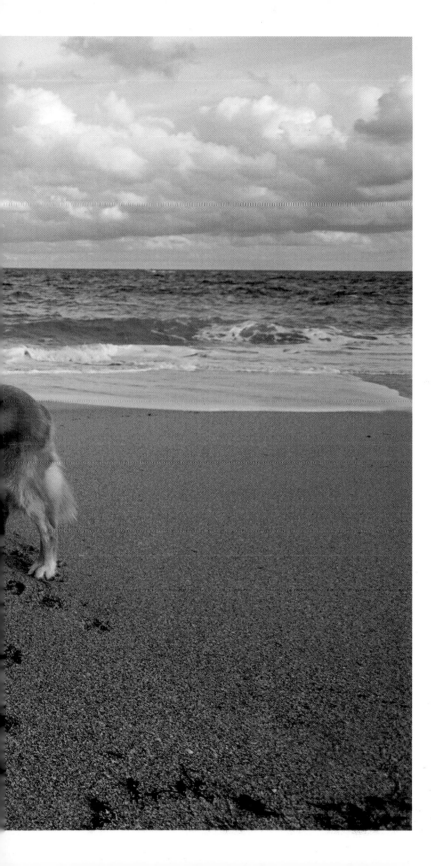

 It happened in 1988, when Jeffrey Shaffner, just beginning his career as a commercial pilot, broke his neck in a boating accident. "It happened so quickly—only a couple of seconds," said Jeff as he motored along in his wheelchair on a Fort Lauderdale beach. His ten-year-old golden retriever, Gann, accompanied Jeff. "The difficult part was the long road to gaining my life back. I was offered a chance to get a dog trained by the Canine Companion Assistance program to help people like me who had lost the use of their arms and legs. I was so depressed and confused, I wasn't sure at first that a dog was what I needed. But I'll tell you, aside from the practical things Gann can do for me (50 commands), I discovered what true companionship and help from a service dog could be. The freedom to go out on the beach, to get as close to the ocean as possible with my dog, this is what keeps my spirits up and my heart pumping. I don't even want to think about what I'm going to do when I have to retire Gann."

75

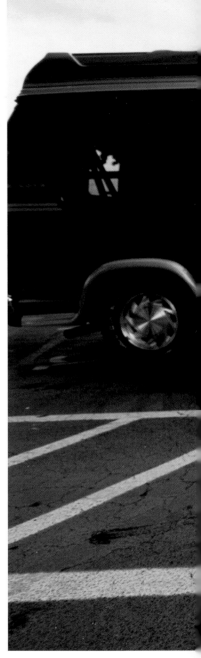

"Gann is what you'd call an 'assistance dog,' as opposed to a guide dog for the blind or a hearing dog for the deaf," said Shaffner as he and Gann started out for a doctor's visit. "Guide dogs for the blind have been around for over 70 years, but the concept of an assistance dog is much more recent. I'll tell you, to have a dog like Gann to turn on lights, help pull me in my wheelchair, pick up keys, and more, what friend could you depend on to do that day after day?"

It wasn't too long ago that a team such as Shaffner and Gann was relegated to the freight elevator on hospital visits. "Most of the medical establishment gets it now, this concept of therapy and assistance dogs," said Jeff as Gann pulled him down the hospital corridor. "But the intangibles with having Gann as a companion are the most important. I need him and he needs me, and everything in between is a gift."

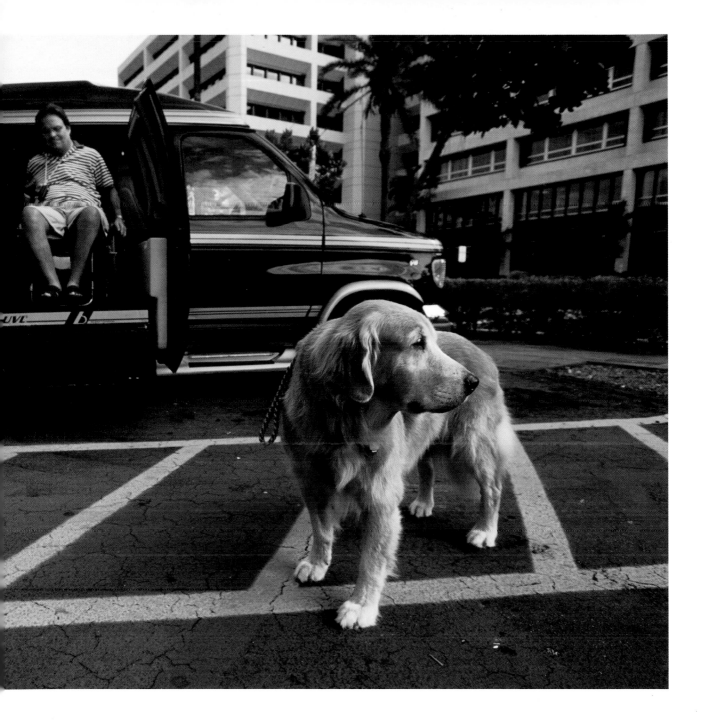

■ On a recent visit to the Children's House at Johns Hopkins in Baltimore, Bailey, a Great Dane, along with his owner, Margo Bechtel, volunteers for the nonprofit National Capital Therapy Dogs. Wearing his Christmas antlers, Bailey easily plays along at the annual Christmas party for children requiring extended treatment at Johns Hopkins Hospital. "There are lots of hoops that I have to go through to qualify a dog the size of Bailey," said Bechtel. "Our dogs have to be trainable, predictable, controllable, and have a temperament to be with children. But those are the specifics. I find the payback for the kids, Bailey, and me to be beyond words. "It's easy for children to forget that there's an outside world, and our dogs reconnect them to that and help take their minds off their sickness. I also work with children who have emotional disorders. When I've had Bailey there at the school, his presence can help ameliorate many of these crisis situations."

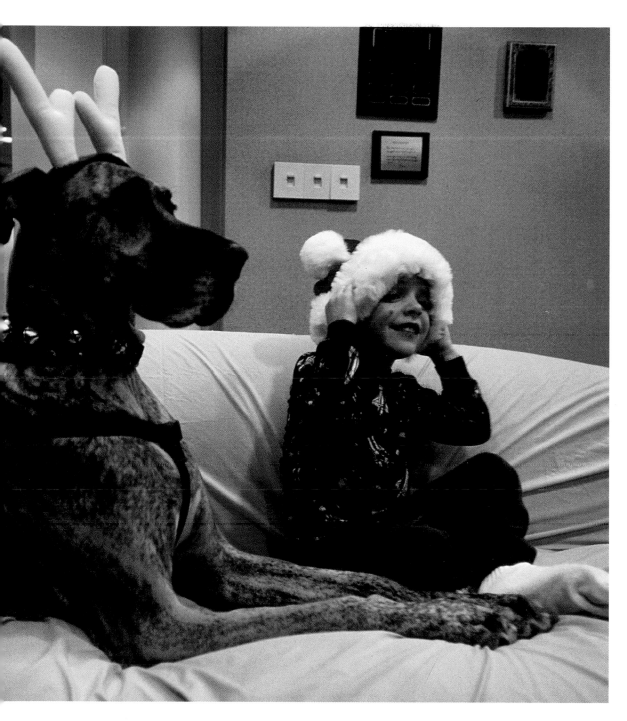

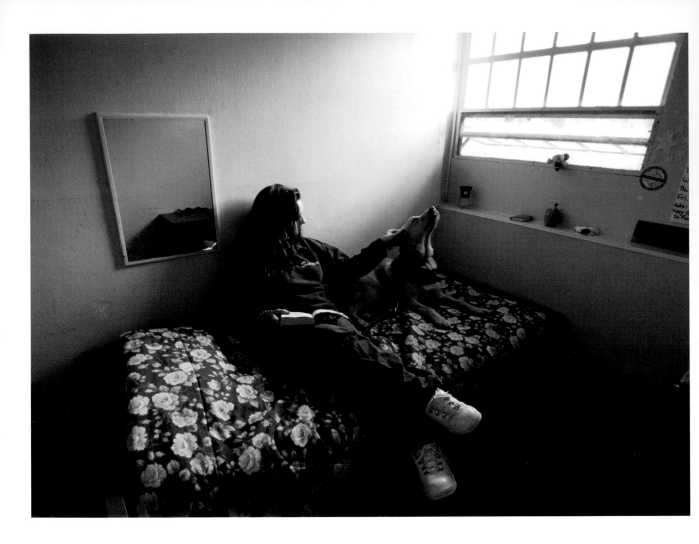

■ As dogs have moved into the world of therapy and assistance, new discoveries have been made, such as the ability of dogs to help young children who have reading problems. "We have found that for some children in our reading program with dogs, their reading levels jump as high as four grades in one year," said Kathy Klotz from her Salt Lake City office of Intermountain Therapy Animals."It's more typical to gain two reading levels, but the fact is that a young child doesn't feel self-conscious reading to a dog. The dog doesn't laugh or care if you stumble over the words. It's hard to believe that the bond between our dogs and these children can have such a profound effect."

"All sorts of wonderful things happen when kids and dogs are put together," said Bonnie Bergin, who started the Assistance Dog Institute north of San Francisco in Rohnert Park, California, 12 years ago. "Our goal is to train our dogs and place them with people with disabilities. We started to have youth at the nearby detention center help us train our dogs. These were kids that you couldn't get through to, you know, very hardened and cynical towards life.

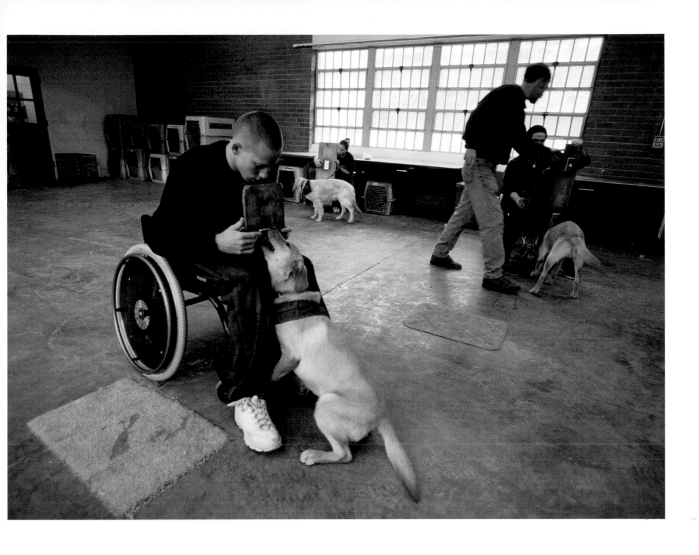

We discovered that these kids really
connected to the dogs, and suddenly
they found some purpose in their lives
in the training process."

"The kids work with the golden
retrievers several times a week," said
Jorjan Powers of the institute. "We match
the kids with one dog, and they train
the dogs to turn on lights, pick up items,
and more while learning to accept their
master's confinement to a wheelchair.
We're also working hard to breed a line
of golden retrievers who exhibit a special
ability to train in this environment for
these special needs."

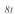 **OPPOSITE** "This is my last day here, and
I'm ready to get on with my life," said
Melissa, petting her training partner,
Pierce, in her room at the detention
center. "This has really been something
for me, working with Pierce. I think this
dog is the first person or thing that
I've ever loved."

Home
on the Range

It was early October in southwest Montana, and already there were some spots of snow hanging on the peaks of the Gravelly Mountain Range. John Helle, a sheep rancher near Dillon, had several bands of sheep summering up in the high country of the Gravellys, a rugged and remote area where coyotes, grizzlies, and wolves compete for food. Helle was in a hurry to get his sheep back across the 10,000-foot Stonehouse Mountain and closer to their winter range in the Sweetwater Basin before the winter storms began. By the time we arrived in John's pickup it was late afternoon, and Victor, a shepherd who is responsible for one of Helle's bands of 1,500 ewes and lambs, was already moving them down to the valley floor of the Ruby River. With him were his four Border collies and two Akbash guard dogs.

"It's been a tough year for our guard dogs," said John as we watched the sheep wind down the hills with Victor and his dogs. "The wolves have been ganging up on them, and though our dogs are tough, Shaggy, a strong Akbash, had his neck ripped open even though he had a spiked collar on. They're really no match for an alpha male wolf. As bad as the losses already are, without these guard dogs we couldn't stay in business."

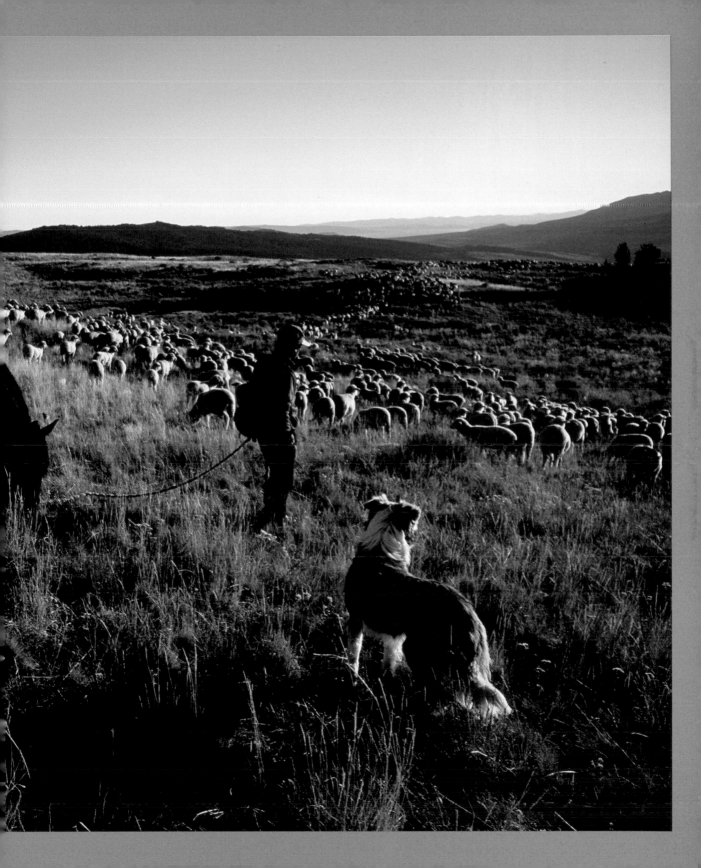

Safely over Stonehouse Mountain, John paused to thank his dogs. "Not only couldn't I get these sheep across the mountains without my dogs," John said, "but working the pens and chutes would be impossible. With margins so slim in the sheep business and with Montana's prolonged drought, we have to do more with less and that's when the dogs really make a difference. We have 28 dogs, and I think we fed them over 300 50-pound bags of food last year." For Helle and his dogs, there are long days of working the pens, where the dogs have to really show their stuff. "We have to sort out thousands of sheep for treatments and of course there's the shearing. It requires

tremendous work from the dogs to keep the sheep moving up the chutes. The dogs have to be trained to move the sheep hard without hassling them. But the Border collie is one of the smartest dogs, and herding is in their blood. These dogs get so obsessive about their work, I'd think twice about having one just as a pet," said Helle. "But sure, I have my favorite. It's Pirate," Helle continued. "He's a black-and-white Border collie, and he's at my side if he's not herding sheep. Unfortunately I had to give him to one of my sheepherders, and now I'm training a new one named Boone. I think Boone is going to be a great dog."

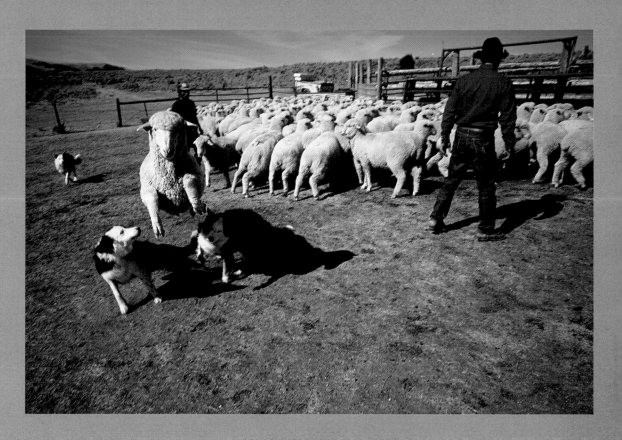

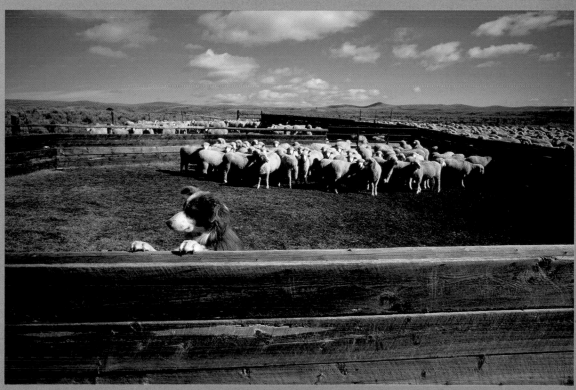

After the sheep have been brought in from
the summer ranges in the high country,
Helle has to prepare them for winter by
running them through the chutes at his
Sweetwater Basin ranch. They have the
wool trimmed around their eyes and are
inspected for diseases or any other
problems. For hours, Helle's Border collies
play a game of cat and mouse with the
ewes, who take any opportunity to bolt
back to the main pen. "Eye contact is very
important for these dogs," said Helle.
"They are spring-loaded, just watching
and waiting for the sheep to make a move.
They anticipate their actions—it's just
incredible to watch—and they can continue
this all day. They never seem to tire, and
at any time I can call them on to the truck
and we go out and round up another few
hundred sheep and start all over again."

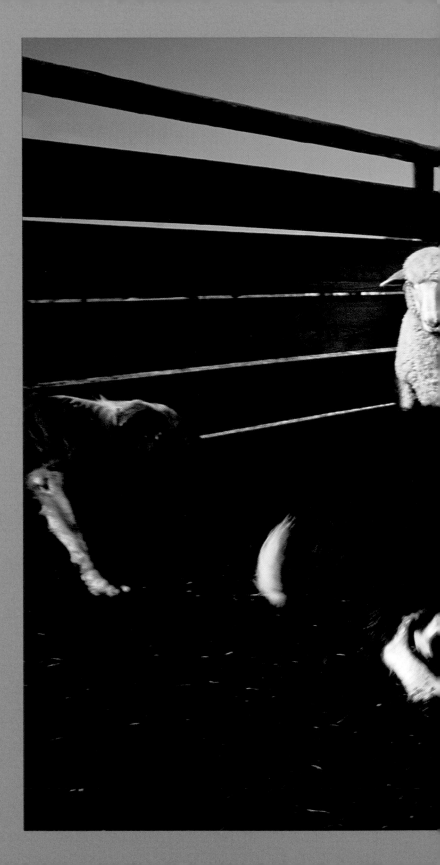

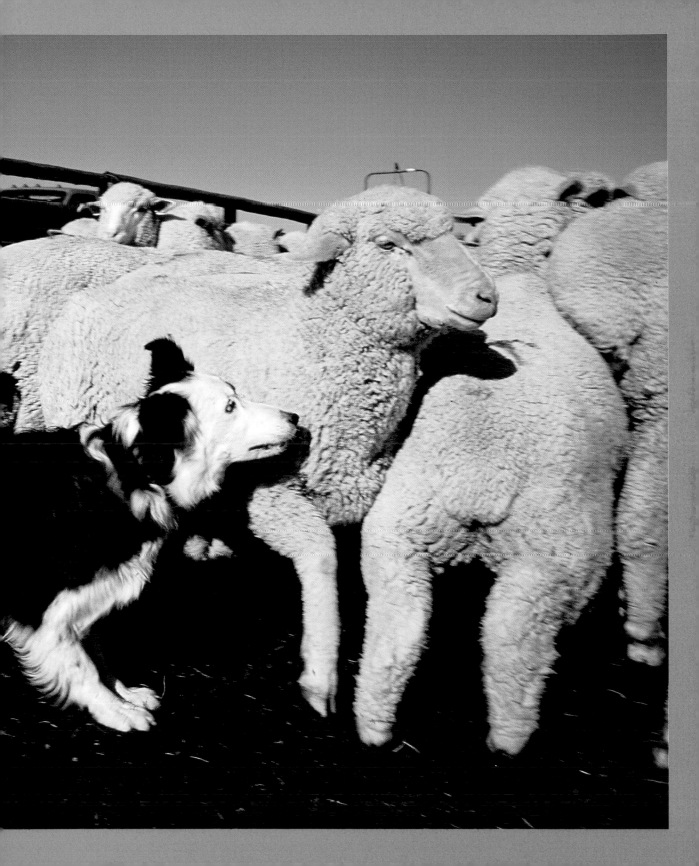

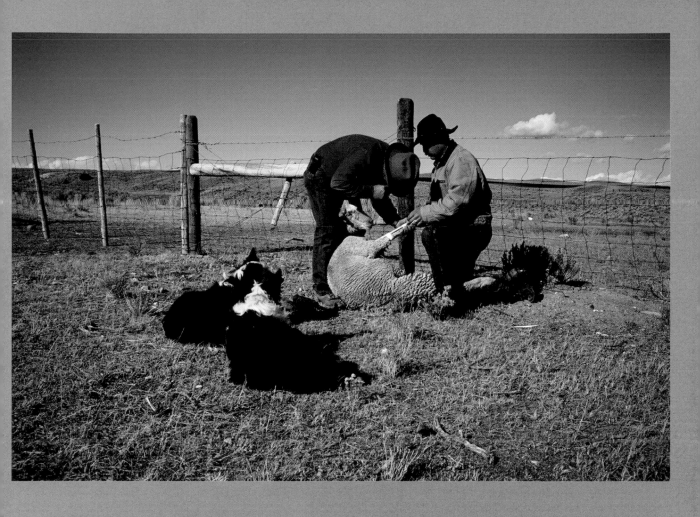

As the sun set along the base of the Snowcrest range, John, with his dog Pirate, rode a dirt bike across a high plateau. It had been a long day, moving several thousand sheep 15 miles across Stonehouse Mountain, through the notch, and down to the Sweetwater Basin. Karen, John's wife, had brought the horse trailers around as well as John's dirt bike, so he could go back and check on Victor, who was bringing up the rear. "I just lost my best old dog, Spike," said Helle. "Karen had to call the vet when I was out of town 'cause she knew it would be too tough on me. Pirate's been a good dog too, better in the pen than out in the open range, but he's always ready to work and I can trust him. I remember my first dog and how I slowly discovered how to train him and how I could get him to work for me," said Helle as he pulled up to Victor's band. "These dogs are so smart, I remember how they started to drive the sheep towards me with just a few whistle commands. They only needed to see me out front and they would work the sheep in my direction."

"So what do you look for in a dog," I asked. "I look for honesty and confidence," said John. "I can tell by looking in a dog's eyes and how he looks back at me. It's in their eyes, this trust thing. Trust is important 'cause I can't be there all the time and they have to be independent, honest, and smart to make the right decisions. Me and my family really depend on that."

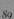

Sheep ranching is a high-maintenance business. One day John noticed that a ewe in a distant pen had broken her leg. "You go corner her, Dilly, you too, Pirate," said John as he and his brother Tom went out to do first aid. The two Border collies had the ewe cornered in seconds, and together the Helles attached a temporary splint. The two dogs sat calmly nearby and watched.

Nathan, 10, sat with Pirate and peered through the fence, watching John. "You know our two oldest boys are so different," said John's wife, Karen. "Evan is into his motorbike, while Nathan loves the dogs and animals. But the two boys feed the dogs every day, and when we have six or eight guard dogs and four or more Border collies home for the winter, well, they have their hands full. But with all of the exposure our children have to the dogs and animals, I tend to think that understanding what it takes to keep this all going will be a positive force for them sometime down the road."

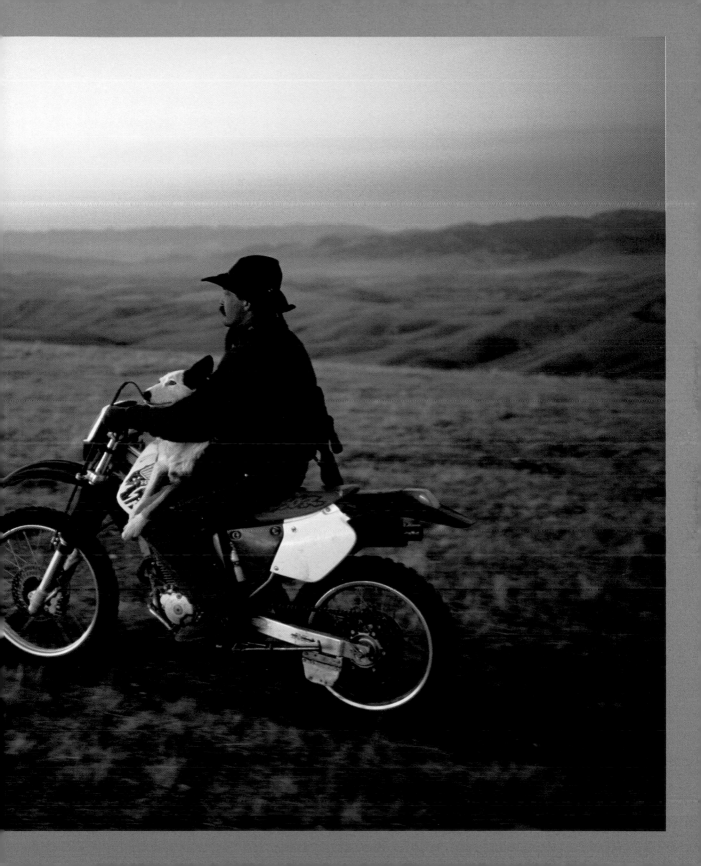

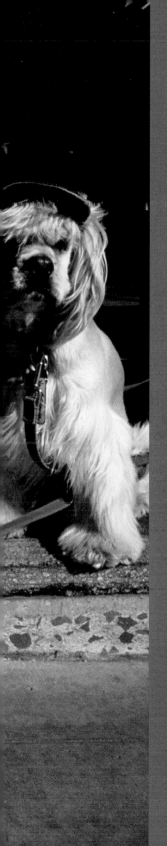

The *Business* of Dogs

"If you pick up a starving dog and make him prosperous,

he will not bite you. This is the principal difference

between a dog and a man."

—Mark Twain
Pudd'nhead Wilson, 1894

Asked if her cocker spaniels help her business, Marilyn Earl, from her Venice Beach, California, hat-and-sunglasses shop, replied, "Listen, Baby, these dogs *are* my business."

When it comes to talking about money and the cost of owning a dog, well, most of us really don't want to have that discussion. Besides, how can we even equate our love for that cute little tail-wagger, sitting patiently alongside the dinner table, with money? Our emotional bond with our dogs seems to have inoculated us against any understanding of the real costs of food, kennels, vet bills, and wear and tear on the old house and car. Our rationalization or avoidance of the issue is simple; we love our dogs and we'll do whatever it takes.

Recently, I sat with a young family in a consultation room with Dr. George Eyster, one of the country's most renowned veterinary surgeons, at Michigan State's College of Veterinary Medicine. It was Christmastime, and this family had recently purchased a cute mixed-breed at the local pet shop. Shortly after acquiring their puppy, they became concerned when it tired easily. Now they were at the vet clinic, listening to Dr. Eyster explain that a heart valve wasn't functioning properly in their dog and that open-heart surgery could repair the problem and give their dog a chance for an active life. The surgery, priced reasonably near $2,000, was certainly not what this family expected from a $50 purchase at the local pet shop. "Doctor, we'll do whatever it takes," was the response from the family.

Ironically, it was only a few short months later that my wife and I were sitting in the emergency room with our German shepherd, Nain, who suddenly took sick and appeared to be near the end. The surgeon explained about internal bleeding from a cancerous growth on Nain's spleen and how the prognosis was not favorable. Several days and several thousand dollars later, after emergency surgery, we had Nain home for his final precious weeks. I now understand the phrase "Doctor, whatever it takes."

"Today in vet medicine, people are asking us to go to extraordinary lengths to save their dogs," said Dr. Eyster, who has been teaching and performing animal heart surgery

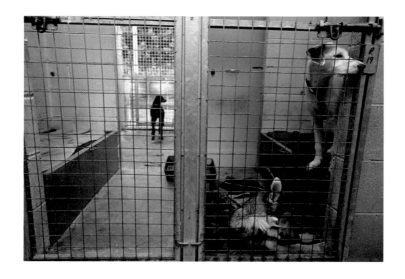

Dogs wait for adoption at London's Battersea Dogs' Home.

for 36 years. "We started out using dogs in heart and kidney research to save humans and now it's being applied back to our dogs. People know it can be done, and they expect heroic efforts to save their pets. They're also willing to pay for it," said Eyster, as he prepared for another heart valve replacement.

It is estimated that in the United States there are more than 43 million dog owners with 68 million dogs fueling a $30 billion annual industry. When you begin to calculate the cost of food, kenneling, bedding, and other dog supplies, you can begin to understand why pet superstores have appeared around the United States and other countries.

One of the most interesting statistics that may explain this economic indulgence is found in a recent survey showing that four million dog owners are more attached to their dogs than to their spouses. It is also estimated that ten million dogs spend the night on the family bed, and one million of those are allowed under the covers. To keep all of these dogs healthy, Americans spend nearly $6 billion a year on visits to their vets.

"There was a time when you'd maybe take your dog once a year for its shots," said Ruth Hoffman, a New York dog handler. "Now it seems it's 20 times a year for some of my customers." Statistically it's closer to three visits a year, but still, veterinary medicine is a huge and important industry.

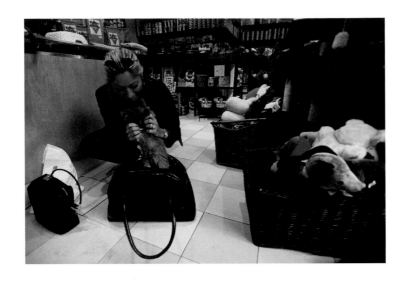

A customer tries out a new doggie purse at Karen's for People Plus Pets, New York City.

Recently I was in Hollywood, California, walking the back lot of Universal Studios with a Jack Russell terrier and his handler. This wasn't just any Jack Russell. This little terrier is probably one of the highest-earning dogs in recent history. His name is Moose, and his journey from farm dog to movie star is legendary. His frequent appearances in print and TV advertising spots, along with his starring role in the movie *My Dog Skip,* are in addition to his role as Eddie, an original and continuing cast member on the TV show *Frasier.*

"I have no doubt that he'll work until the show closes in a couple of years," says Mathilde DeCagny, his longtime handler. "His son Enzo stands in for some of the tough parts," said Mathilde, "but nobody will replace Moose." A cast member told me that when the show first began, Eddie was getting so much fan mail and media attention that the producers decided to cut back his on-camera shots. DeCagny won't confirm the estimate I've heard that Moose makes $10,000 a month when he's working on *Frasier.* Later that evening on the set of *Frasier,* lead star Kelsey Grammer approached me. "I suppose you're here to take a picture of Eddie?" he said, as he turned away in mock disgust.

The appearance of dogs in folklore, religion, art, and literature precedes such celebrities as Rin Tin Tin, Lassie, and Eddie by thousands of years. The early Romans recorded

many stories about their dogs' courage and fidelity, and some 4,000 years ago the Chinese chronicled stories about important dog trainers and their kennels. Dogs are portrayed in ancient Egyptian art dating back 6,000 years.

But in the 20th century dogs began to appear regularly in movies and advertising, ushering in a new form of commercialism in which advertisers understood and exploited the power of our canine connection. Today, some of the more touching and humorous advertisements are those for dog supplies and medicine.

But in spite of the tremendous growth in dog ownership and all the money that is spent on them, millions of dogs from around the world are abandoned each year, costing governments billions of dollars to impound and euthanize them. It is estimated that communities within the United States alone are obliged to put down three million dogs each year. Taxpayers annually pay upwards of $2 billion to deal with homeless pets.

Over the past decade, however, humane societies and animal rights groups have strongly promoted rescuing, neutering, and re-homing displaced or abandoned dogs in an attempt to cope with the problem. A simple search of the Web uncovers hundreds, if not thousands, of concerned groups and organizations working to deal with these issues.

My plane touched down at Heathrow Airport and I took a cab to southwest London, where the Battersea Dogs' Home is located. Battersea Dogs' Home is one of the world's oldest and best known animal shelters. It has been caring for London's unwanted dogs and cats for more than 140 years and is a showcase example of how cities can deal with their unwanted or abandoned dogs. The shelter was started in 1860 by Mary Tealby, who late in life developed a passion to rescue unwanted dogs. Over the years, her shelter grew into a huge complex, with multistory kennels that can house more than a thousand dogs.

"But this is not about picking up strays and locking them away," said Helen Tennant, Battersea's communications director. "This is about rescuing, rehabilitating, and finally re-homing our dogs with people who truly want a pet." I followed Ms. Tennant into the newest building in their huge complex, the Tealby kennels, which contains about 120 modern kennels neatly laid out over four floors.

"Our vans go out every day and bring back strays collected by the police. Our goal is to bring them back, clean them up, make sure they're healthy, socialize them if necessary, and find a new home for them as quickly as possible," continued Tennant. "Most important, we do not put down a healthy dog here at Battersea."

It was mid-morning and the doors had opened to a typical crowd of families, couples, and individuals who had lined up to apply for a dog. One doesn't simply show up and pick out a dog here. The first step is to fill out forms that ask questions about yourself, your family's lifestyle, ages of children, and other factors that help determine what might be the most successful match.

If the staff determines that you qualify, you're turned loose to wander the floors and go from kennel to kennel to see if there is one particular dog that tugs at your heart. "This is where the emotions run pretty deep," said Tennant. "The dogs want to be loved and the people want to love them, and you can feel the emotion flowing." It is true. I wandered alone for a couple of hours watching the search for a canine companion and the emotional interaction between people and dogs. If a suitable dog is found and available, the family or persons meet with the dog in a separate room and are allowed time to see if a bond develops. A counselor also visits, going over details about the dog and any medical issues while also watching the interaction between the prospective new owners and the dog. The unusual thing about Battersea is that after the successfully re-homed dog leaves with its new family, it can expect a visit at home by a counselor some days or weeks later to see how things are working out.

"It's not often that we take them back," said Tennant, but "we've gone the extra mile to make sure these homeless dogs have finally found a place for life."

The impact of what is accomplished at Battersea Dogs' Home showed itself the next Sunday during the annual Battersea Reunion of Rescued Dogs. The expansive park quickly filled with more than a thousand people, who paraded their dogs around in a carnival-like atmosphere. Many entered the various dog shows and demonstrations that showed off newly acquired handling skills. In true British style, there was a show for "best dressed" dog. It was hard to imagine that all of these dogs at one time or another had been abandoned or abused and that a staff of dedicated dog lovers, backed by their community, could affect so many canine and human lives. It is a paradox that such a large number of unwanted or abandoned dogs exist in this world while legions of pampered pooches support a huge multibillion-dollar industry.

The evolving business of breeding, feeding, boarding, and doctoring of our dogs is only part of a complex relationship, one that is about to take on a bold new direction most of us never have dreamed possible.

Just outside of Mill City, California, on a misty hill overlooking the Pacific Ocean, I walked with a dog that might change world history. Her name is Missy. She's a

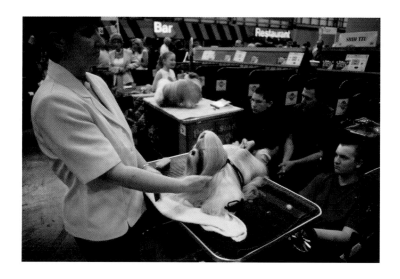

Preparing for the shih tzu competition at Crufts Dog Show.

beautiful but aging collie-husky mix, whose wealthy owner (whom I promised to keep anonymous) is funding a multimillion-dollar effort called the Missplicity Project to clone his dog. He has hired a businessman named Lou Hawthorne to start and coordinate the work at a company named Genetic Savings and Clone, located in College Station, Texas. Last year they achieved the world's first successful cloning of a cat, but their real goal is to clone Missy.

"Dogs have a complicated reproductive system," said Hawthorne as he stroked Missy's soft head. "I have no doubt we'll succeed; it's just a matter of time. There are so many people who have an incredibly deep attachment to their dogs, that once this is perfected I know many will want to clone their dogs." Today in College Station, there sits a stainless-steel tank filled with liquid nitrogen and DNA samples from hundreds of dogs, as owners wait for a breakthrough.

My walk with Missy was short, but it made me think about my time in Israel with the ancient Natufian dog and its mistress. Humans and dogs have traveled an incredible span of time and history together. But I'm sure that from the very beginning days of this journey, there has always been a special place in our hearts for our dogs, one that is deep, enduring, and wonderfully unexplainable.

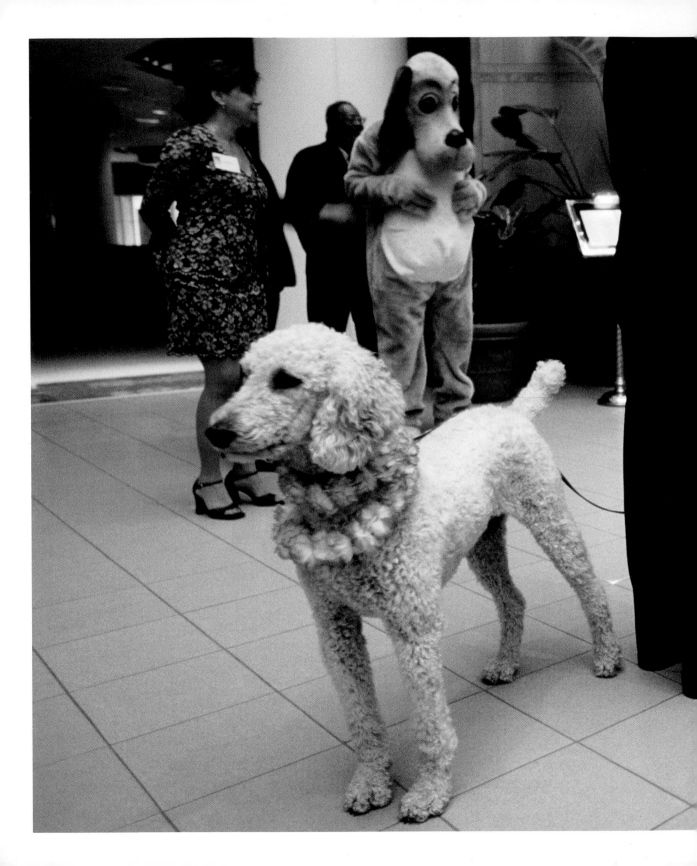

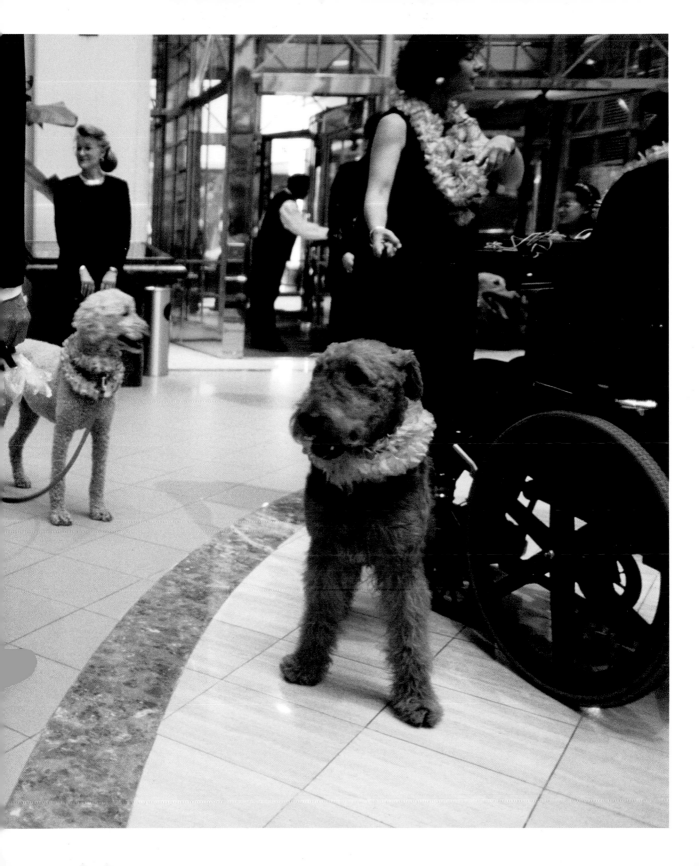

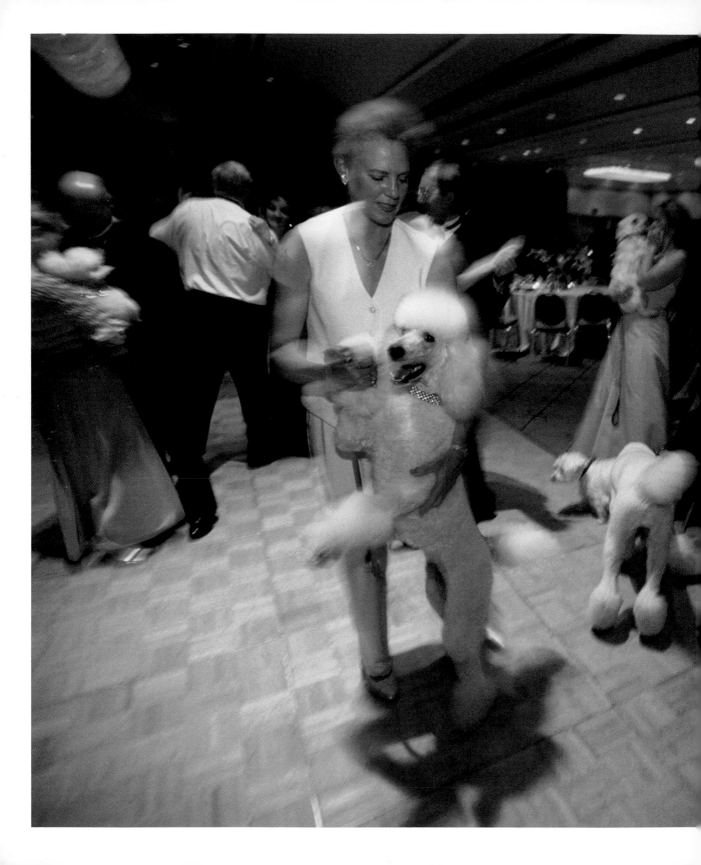

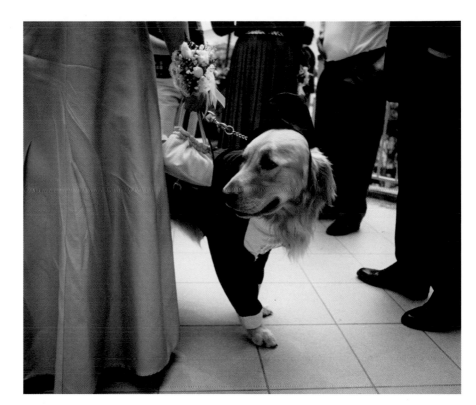

■ The challenge for humane societies around the world is how to handle and pay for all of the millions of dogs abandoned each year. It is estimated that in the United States alone, more than $2 billion is spent on this problem. The Washington Humane Society, like others, tries various ways to raise money for its programs. One is the 15-year tradition of the "Bark Ball," a black-tie event priced at $200 a guest. Dogs are not required, but most people bring theirs. The ball usually draws 600 guests with about 200 dogs at a sit-down (watch the handouts from the table) dinner. Some will dress up their dogs in hats and tailcoats, while others are satisfied with a neck scarf or a simple Hawaiian lei. After the meal, people pose for pictures by a professional photographer and dance with their dogs to a swing band.

■ PRECEDING PAGES Guests at the Washington Humane Society's Bark Ball parade proudly around the hotel lobby with their dogs.

■ The groomers, eight of them, were dressed in black jumpsuits. The steady sound of blowers and clippers was almost loud enough to require ear protectors. "Who's got the 10 o'clock poodle?" Randy asked from the doorway. No one heard him above the roar. The tables were filled with ten dogs, all in various stages of trimming, finishing, and final fluffing. Two Maltese were being washed in the oversize Kohler tub. "It's amazing how people want their pets to look better than themselves," said Karen, of Karen's for People Plus Pets, an upscale Manhattan pet-grooming and -supply emporium "In this kind of neighborhood, people have no limits on what they will do for their dogs. Many of our clients will give their dogs $450 worth of grooming a month. Now think about it, that's $50,000 over the life of a dog, just for baths and haircuts." Karen's 10,000 yearly grooming appointments make this a big business. Americans spend $30 billion on their pets each year, nearly 2.5 times the gross domestic product of Haiti. Enterprising stores like Karen's have ridden the crest of that wave for many years. Only in the past decade have pet superstores begun to position themselves in malls across the United States, pushing out the small mom-and-pop pet shops. Today, the two chain stores of PETCO and PETsMART have more than 1,100 superstores in the U.S. and Canada, with over $3.5 billion in sales.

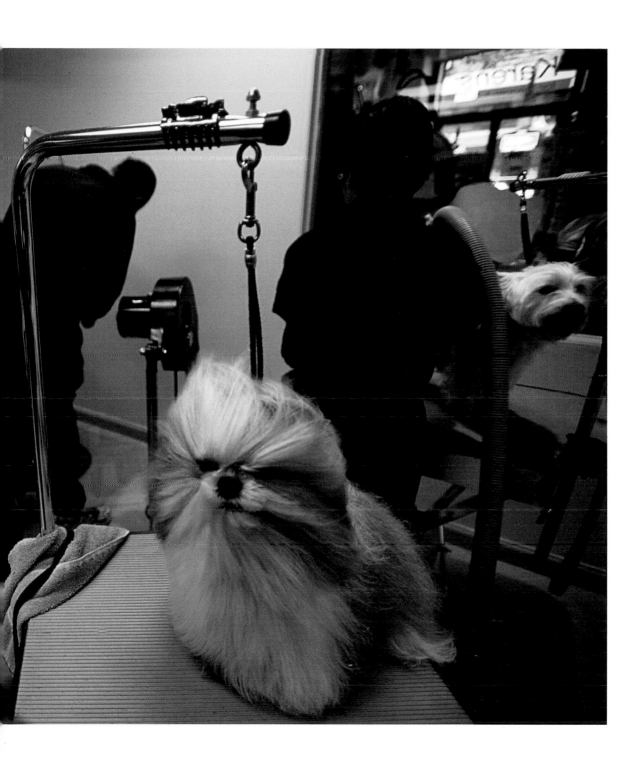

■ An orphaned terrier-mix, one of 3,000 orphaned dogs brought to the well-known Battersea Dogs' Home in London this year, now waits for adoption or "re-homing." "Our goal is to take in every dog and restore it to its former glory," said Helen Tennant, of Battersea Dogs' Home. "First they go to our clinic for evaluation and any needed medical care. Then they're washed, profiled for disposition, and then placed for viewing. We have a strict policy that no dog is euthanized unless it is beyond saving for serious social or medical reasons. What's troubling is that some people think that because they have an old dog and don't want to pay the last vet bills, they can just abandon it. These dogs have given years of love only to be discarded. It's shameful."

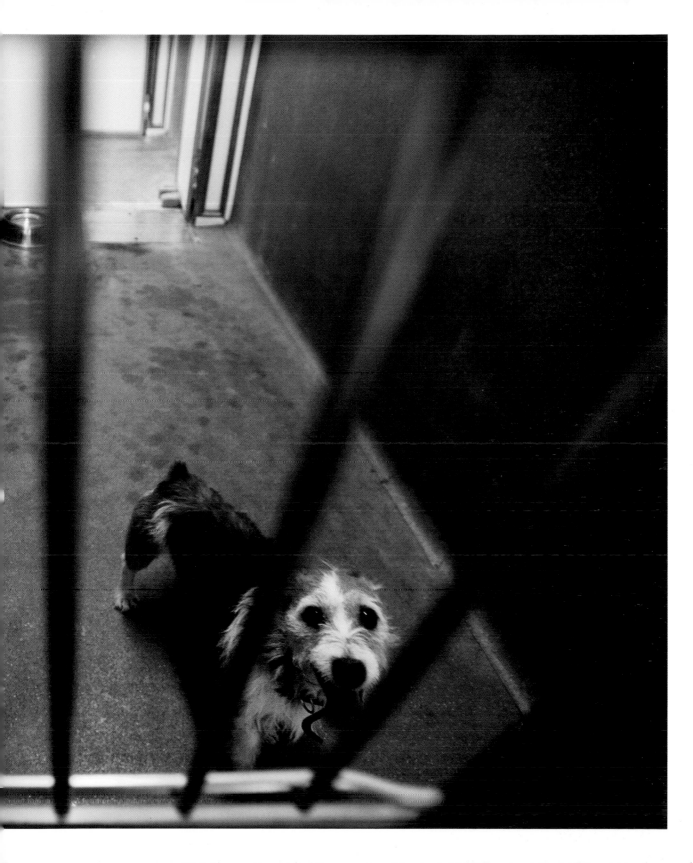

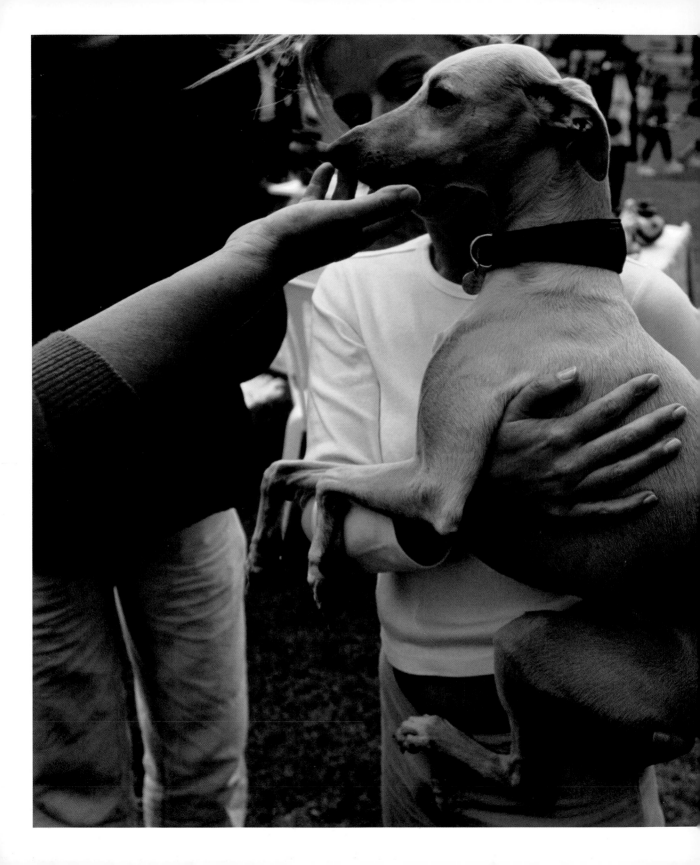

■ **LEFT** Beginning in 1995, the Home decided to hold an annual reunion at nearby Battersea Park for owners and their rescued dogs. It started out with only a handful of people, but quickly grew. Last year's reunion had 3,000 dogs and 7,000 people mixing together, sharing stories, and competing in various events and games. "It's our way of staying in touch with the dogs and their families, and we've created a sense of belonging to one of the great rescue efforts," said Tennant. "We all get a bit wacky over our dogs, don't we, and this is the time and place you can do it without embarrassment."

■ **BELOW** "I guess this is the best for all of us even though it's a real commitment of time," said Tony Puerto as his family warmed up to a pit bull, one of the few, and highly sought after, puppies at Battersea. It's anything but routine to adopt a dog at Battersea Dogs' Home. Forms and questionnaires must be filled out, and personal interviews by staffers weed out problem areas, such as the ability to afford a dog's medical costs or whether work schedules leave a dog home alone all day. "If a family passes the first tests," said Tennant, "we put them in a room with the dog for an hour or so to see how they bond and then we interview them again. The last thing we want is to mismatch the dog with its new family."

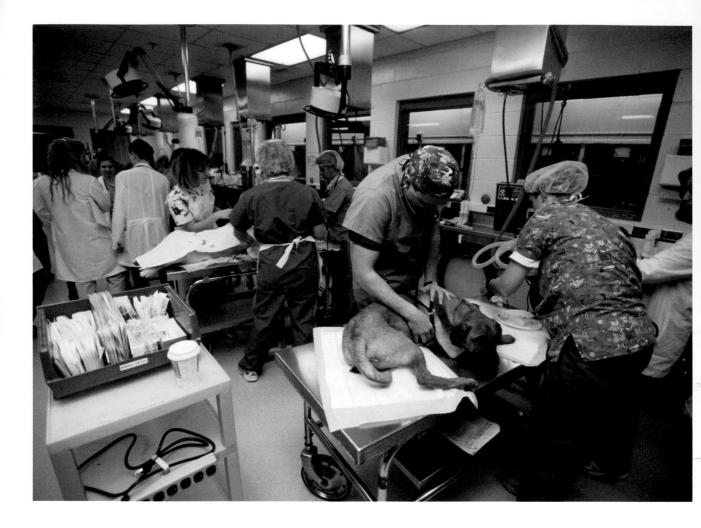

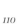 David and Amy Kesling bought a Labrador shepherd-mix for their daughter at a Michigan pet store around Christmas and were told that it had a slight heart murmur. But their dog, named Bailey, seemed to tire easily. When they brought him to the clinic at Michigan State's University College of Veterinary Medicine, cardiologist and professor George Eyster discovered it was much more serious. Bailey needed heart valve repair to survive. With a child on the way, a $2,000 bill for heart surgery was not what the Keslings had anticipated. "We fell in love with this dog and we couldn't give it back because who knows if anybody would make the effort to save its life," said David. "I didn't want to take that chance and have someone put this dog down because of the money." Dr. Eyster successfully operated on Bailey, and just few days later Bailey was on his way back home with the Keslings. "It's always a tough decision about how much money to spend on your pet," said Dr. Eyster,

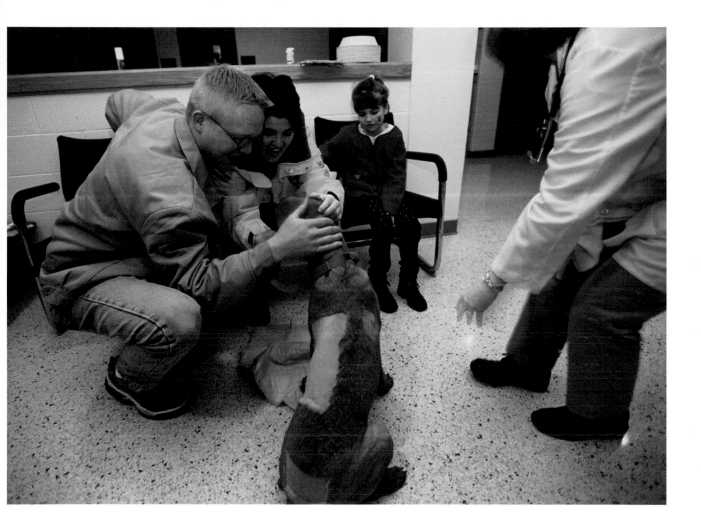

"but when you see the family leave with a success like this, you know there's a bond with their dog for a lifetime.

"There has been a tremendous change in veterinary medicine," says Dr. Eyster, who has performed thousands of open-heart surgeries over his 36-year career at the college. "I don't think people cared any less for their dogs 30 years ago, but today's technology enables us to do for dogs what we can do for humans, and people expect that of us now. And if you look around, you'll see there has been a complete gender change in our field. Once, it was male dominated. I had one woman in my class when I went through school, and now a high percentage of students entering colleges of veterinary medicine are women. We have 1,500 applicants for 100 positions, and most of these are women. This is great because I think women vets can have a very empathetic and tender touch, and today that's what families want and expect when they bring their dogs in for care."

■ Long before the era of film and television, dogs entertained audiences alongside itinerant performers. In the 1700s dogs entered the circus ring with acts of physical adeptness, such as jumping through flaming rings and numerous other acrobatic stunts. In the early days of silent film, heroic feats of canine loyalty were portrayed by a famous military dog named Rin Tin Tin. Today's baby boomers will remember a reincarnated version of Rin Tin Tin and a new star called Lassie from a series of half-hour television episodes that aired in the 1950s. We also grew up with dog cartoon characters such as Pluto and Goofy. But it wasn't until Walt Disney brought us such classics as *Lady and the Tramp* and *101 Dalmatians* that dogs in our pop culture began to be routinely anthropomorphized or made to behave like humans. On the set of the popular television sitcom *Frasier*, the original Jack Russell terrier, named Eddie (his real name is Moose), is usually the center of attention between takes. "Moose is getting on in years," says Mathilde DeCagny (striped sweater), "but I have no doubt he'll work until the show closes in a couple of years." You won't hear any complaints from cast stars Kelsey Grammer, David Hyde Pierce, John Mahoney, Peri Gilpin, or Jane Leeves about the popularity of Eddie, even though it was rumored producers had to cut back on the camera time for Eddie because his fan mail was getting, let's say, a bit out of hand.

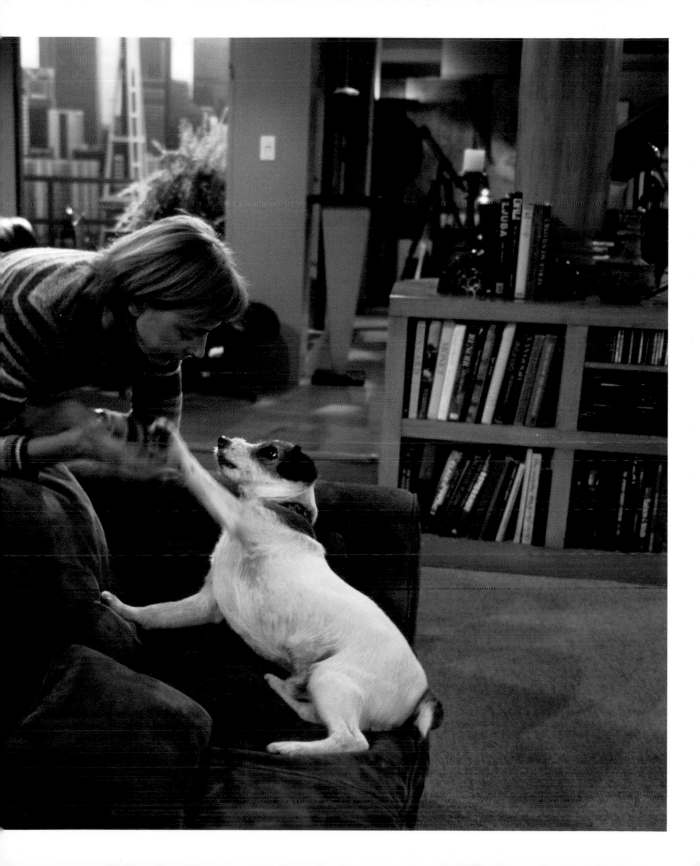

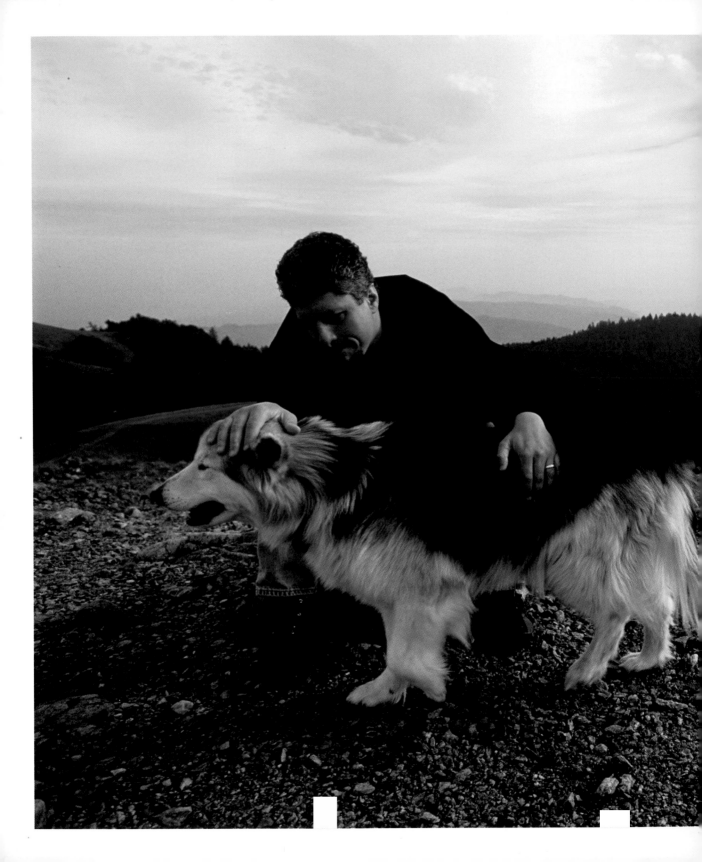

 A recent e-mail from Lou Hawthorne, CEO of Genetic Savings and Clone read, "Missy, the beloved dog who has inspired a multimillion-dollar canine cloning effort, recently died under a magnolia tree surrounded by family." I had visited and walked with Missy and Lou Hawthorne on the hills overlooking the Pacific Ocean west of Sausalito, California, just a short time before. Missy, owned by a wealthy Arizonan, became the focus of a massive and expensive race to clone pets by nuclear transfer. With Genetic Savings and Clone's recent success in creating the first cloned cat, CC, Hawthorne feels Missy's clone is near. "We wanted to achieve this with Missy still alive," he said, "but we have tissue samples of Missy preserved in liquid nitrogen in our College Station, Texas , office and there is more than enough to continue the research."

"I won't tell you how many pet samples we have at our facilities," said Chuck Long, general manager at GSC. "But there is already a large number of people who want to carry on the genetic history of their loved companions, and they are entrusting that legacy with us."

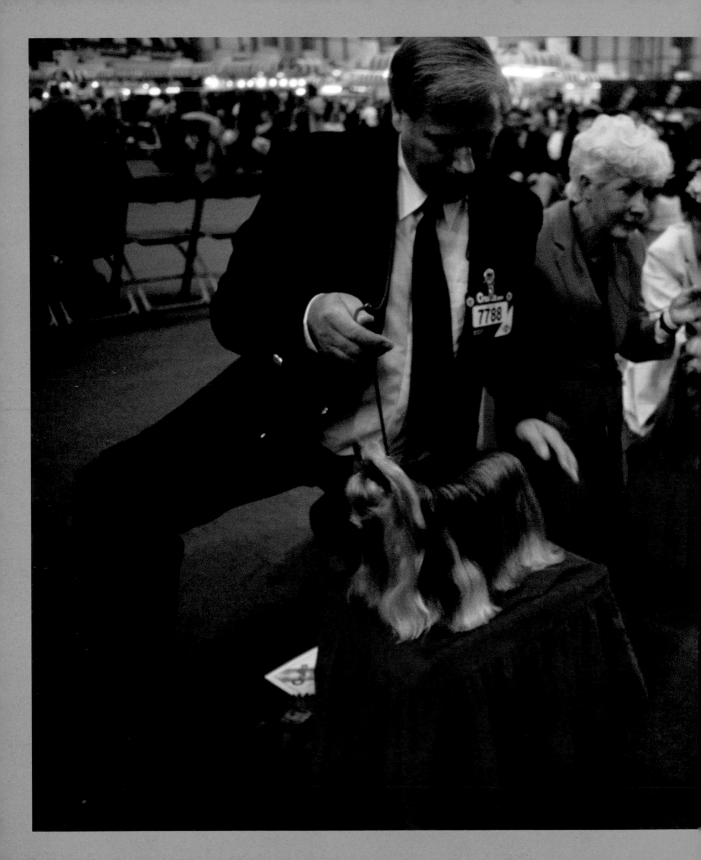

The Greatest
Show on Earth

As dogs evolved, their owners discovered they could crossbreed special characteristics of their favorite dog to another with different desirable traits, in an effort to produce hybrid results in their offspring. Subsequently we've ended up with hundreds of breeds that range from the 190-pound mastiff, a Roman war dog in antiquity, to the diminutive Yorkshire terrier, which English coal miners carried in their pockets to hunt rats in the mines. In the 1800s enterprising English promoters started to bring dogs together in shows and exhibitions, many of which turned out to be corrupt and unhealthful. To regulate these dog shows and promote a concept that a dog registered with a club was superior to any common dog, the English formed the Kennel Club in 1873. Noting the success of European dog shows, the Westminster Kennel Club started holding shows in New York beginning in 1877, making it one of the longest running sporting events in American history. In England, a dog-food salesman named Charles Cruft began promoting a dog show in 1891 that over its 111-year history has grown to be the biggest of dog shows, drawing 150,000 people and 25,000 dogs from around the world.

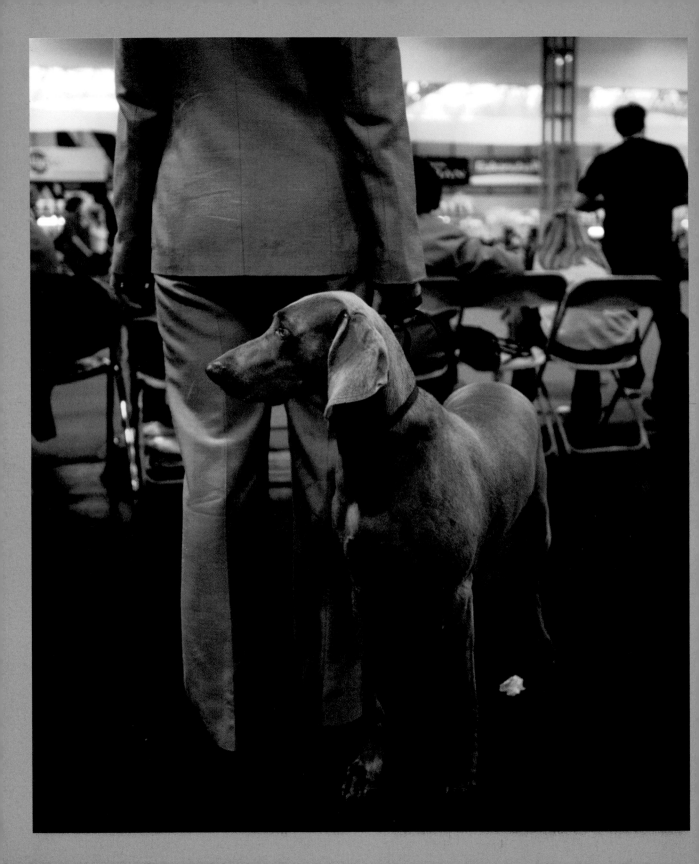

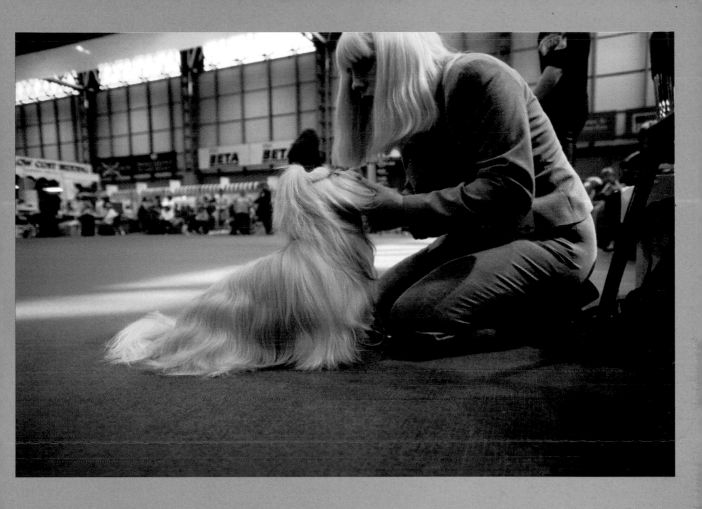

Shows such as Crufts, in England, or the prestigious Westminster Kennel Club Dog Show, hosted by the American Kennel Club in New York, are as busy as a 30-ring circus. It is impossible to see all the competitions or even a majority of Crufts' 25,000 dogs. Fortunately, each day focuses on a different group, giving spectators a chance to develop a game plan. One day is reserved for toy and utility breeds such as the shih tzu or bichon frise. Other days are reserved for the hounds and terriers or gun dogs and working dogs. The gun-dog competition at Crufts, for example, has 27 breeds in 32 rings. By the end of their day, 5,500 entries have been judged. "It really is no more than a beauty contest," said Phil Green, who brought his Bernese mountain dog to the show. "But what's interesting is that a beautiful and graceful dog like the Afghan hound is judged on one level, while the shar-pei, with its drooping, folded skin, finds its beauty on another." After viewing hundreds of different dogs, it's really hard to imagine that the family tree of all these diverse-looking dogs started with the wolf. On the first day at Crufts I watched the shih tzu competition, in which 237 low-slung, hair-dragging pooches paraded around in circles for hours, their owners brushing them continuously between sessions. How can you possibly pick the best? "Easy," said judge M. Cole, "you go for poise and beauty. I can spot it from across the hall."

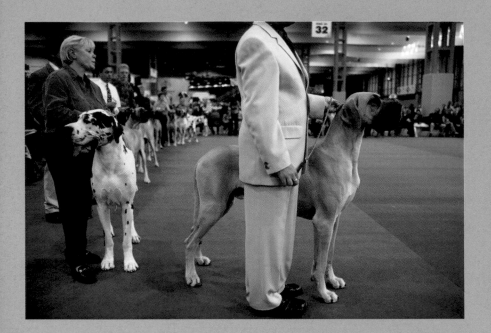

The process of selecting Best in Show begins
with individual breeds competing against
each other. Then those winners face off
against similar breeds for Best in Group.
On the final evening, the group winners
enter the main ring to be paraded, posed,
and inspected before the judge awards the
prestigious Best in Show. No one breed
seems to dominate. Since 1928, greyhounds,
West Highland white terriers, German
shepherds, Irish setters, Great Danes, and
bulldogs, to name a few, have won. In 2001
a basenji, a primitive African dog, took top
honors. A standard poodle won in 2002.

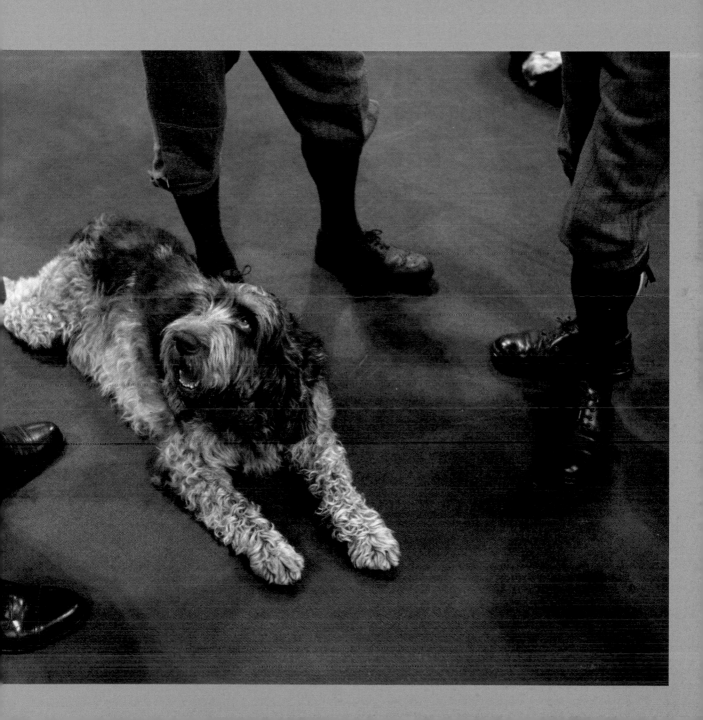

Dog shows run by the kennel clubs have helped standardize breed characteristics, and in many cases rescued breeds sliding toward extinction. Bulldogs almost vanished after bull-baiting was banned in England in the 1830s. The Dalmatian, which was bred as a carriage dog and used in the 1800s by fire departments to control the horses pulling the engines, faced a similar fate. The Irish wolfhound (right), used by Celts to hunt wolves, almost vanished in the mid-1800s before it was revitalized in the second half of the 1900s.

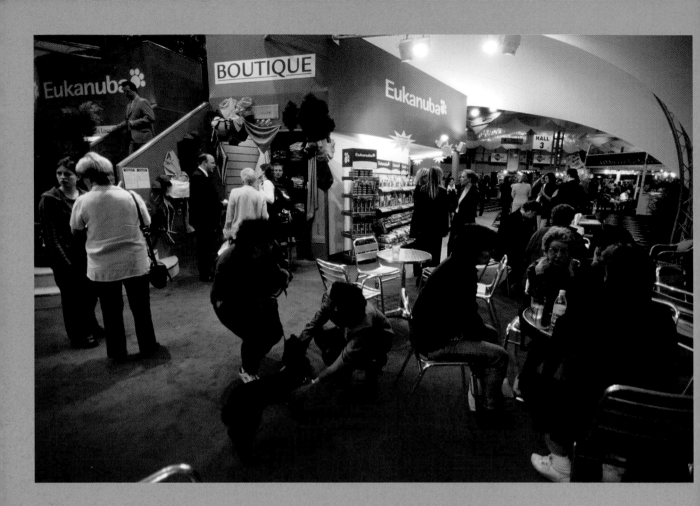

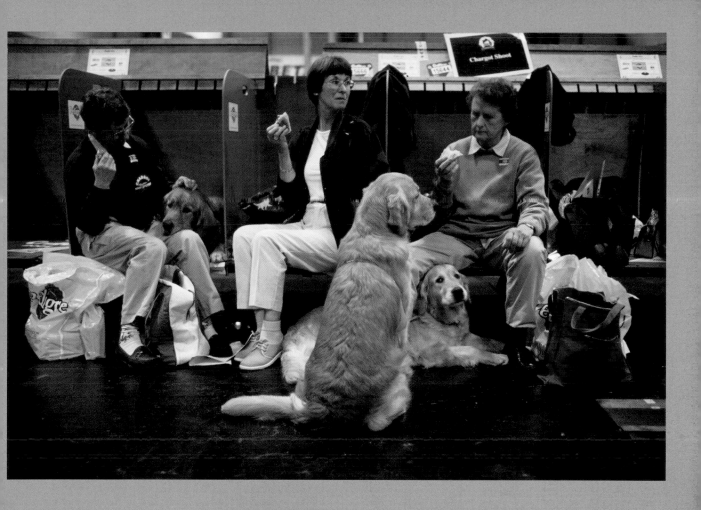

The dogs endure endless hours of waiting and grooming in preparation for a very short time in the judging ring. Although golden retrievers (above) are often the breed with the most entries, they have never snared a Best In Show at Crufts or Westminster. The golden is a good example of how a dog's usage has changed dramatically over time. Known for their gentle mouth and disposition, they were initially bred to retrieve waterfowl. Yet over the years their docile personality, especially with children, had them pegged for life in the suburbs. With this popularity came extensive over-breeding and some genetic problems. Today, some lines of golden retrievers are being bred as assistance dogs for the disabled. If there is any doubt that dogs are big business, one has only to walk the hallways at Crufts or Westminster and see the expansive and costly vendor displays showing every kind of dog food, service, or product you can imagine. Like Charles Cruft, who saw dollars in dogs nearly a century ago, promoters today know that the people-dog relationship is a powerful economic combination.

"Roonie is home-bred," said Karen Knott, talking about her four-year-old weimaraner from her home in Creech, Dorset, England. "This gives me real satisfaction, being a winner at Crufts, especially when there's no big money behind our operation." Karen and her husband, Stuart, have four dogs. Stuart runs Lurchers, while Karen has two weimaraners. "Anni is the mother, and her boy, Roonie, is the show dog. His real name is Jarman Frosty Jack, but we know him as Roonie. He also hunts, so I'd say he's dual purpose," said Karen. "We've gone to Crufts with Anni and Roonie four years now. Roonie is so different from his mom, who is a reluctant field-trial dog. Ronnie is so handsome and he loves to show. He can handle all the attention, and the clapping doesn't faze him. He has that sparkle in his eye and when he looks at me, well, I'll tell you, I just melt. He won some Best Dog titles in his class and now at Crufts he's won first place in Limit Class, which is reserved for more experienced dogs with previous winnings. But this is just a hobby for me,"

said Karen, trying to convince me that she has this dog thing in perspective. "Now Kerry, my daughter, (opposite) is at Crufts for the first time and she is getting hooked too. The day's exhausting for Kerry, but she sees her Roonie in a different light after he's won first place in his class. She's given some reports at school about the whole experience, and she loves telling her friends about the dog show event." When I asked Karen why she favors weimaraners over other breeds, she paused. "I know not everyone will agree with me," she said, "but weimaraners are unlike any other breed that I know of. They seem almost human, and they can express themselves with so many different looks. I think these dogs are natural clowns and my two 'weimies' keep us laughing. Roonie understands all of my moods, and I think I understand many of his. I have my friends, sure, but dogs are always there for you. That's what this is all about, isn't it?"

127

Dog Stories
Richard Olsenius

PUBLISHED BY THE NATIONAL GEOGRAPHIC SOCIETY

John M. Fahey, Jr., President and Chief Executive Officer

Gilbert M. Grosvenor, Chairman of the Board

Nina D. Hoffman, Executive Vice President

PREPARED BY THE BOOK DIVISION

Kevin Mulroy, Vice President and Editor-in-Chief

Charles Kogod, Illustrations Director

Marianne R. Koszorus, Design Director

STAFF FOR THIS BOOK

Lisa Lytton, Editor

Rebecca Lescaze, Text Editor

Bill Marr, Art Director

Gary Colbert, Production Director

Richard S. Wain, Production Project Manager

Meredith C. Wilcox, Illustrations Assistant

MANUFACTURING AND QUALITY CONTROL

Christopher A. Liedel, Chief Financial Officer

Phillip L. Schlosser, Managing Director

Clifton M. Brown, Manager

One of the world's largest nonprofit scientific and educational organizations, the National Geographic Society was founded in 1888 "for the increase and diffusion of geographic knowledge." Fulfilling this mission, the Society educates and inspires millions every day through its magazines, books, television programs, videos, maps and atlases, research grants, the National Geographic Bee, teacher workshops, and innovative classroom materials. The Society is supported through membership dues, charitable gifts, and income from the sale of its educational products. This support is vital to National Geographic's mission to increase global understanding and promote conservation of our planet through exploration, research, and education.

For more information, please call 1-800-NGS LINE (647-5463) or write to the following address:

National Geographic Society

1145 17th Street N.W.

Washington, D.C. 20036-4688 U.S.A.

Visit the Society's Web site at www.nationalgeographic.com.

About the Authors

Richard Olsenius is an award-winning photographer, filmmaker, and former photo editor at National Geographic. His work has appeared in ten books and more than fifteen stories for the National Geographic Society. His most recent book, *In Search of Lake Wobegon,* was a collaboration with Garrison Keillor.

Angus Phillips is an outdoor writer for the *Washington Post.* He has authored hundreds of articles, including a story with Richard Olsenius on the evolution of dogs for NATIONAL GEOGRAPHIC magazine.